IMAGES
of America

COLFAX COUNTY

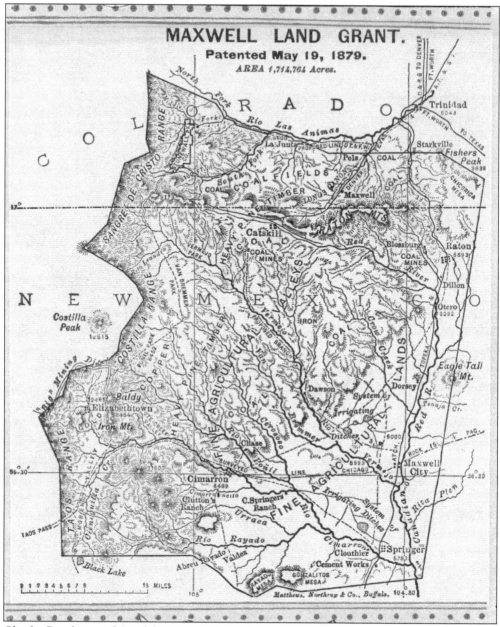

MAXWELL LAND GRANT.

Patented May 19, 1879.

AREA 1,714,764 Acres.

Charles Beaubien and Guadalupe Miranda received a grant of land from the provincial governor of New Mexico, Manuel Armijo, in 1841. Beaubien's son-in-law Lucien Maxwell initially settled the grant and later acquired it through inheritance and purchase. The grant as it was laid out comprises most of present-day Colfax County, New Mexico. In 1887, the Supreme Court of the United States confirmed that the grant held 1,714,765 acres. (Philmont Museum.)

ON THE COVER: Manly Chase traded 1,000 head of horses to Lucien Maxwell in 1869 for ranchland in Ponil Canyon located northwest of Maxwell's Cimarron ranch headquarters. Chase's eldest son, Mason, pictured here with some of his cowboys in 1924, managed his father's ranch for many years. It extended through much of the Ponil and Chase Canyons. (Philmont Museum.)

IMAGES
of America
COLFAX COUNTY

Stephen Zimmer and Gene Lamm

ARCADIA
PUBLISHING

Published by Arcadia Publishing
Charleston, South Carolina

Library of Congress Control Number: 2015941072

For all general information, please contact Arcadia Publishing:
Telephone 843-853-2070
Fax 843-853-0044
E-mail sales@arcadiapublishing.com
For customer service and orders:
Toll-Free 1-888-313-2665

Visit us on the Internet at www.arcadiapublishing.com

To Jane Arellano Garcia (1932–2015),
Cimarron native, Dawsonite, and a gentle soul

CONTENTS

ACKNOWLEDGMENTS

The authors wish to extend heartfelt thanks to the following friends and colleagues who generously gave of their time and expertise in assisting us in gathering the photographs and illustrations for this book: Linda Davis of the CS Ranch, Jane Garcia, the Hickman family, the Lambert family, Steve Lewis of Eagle Trail Press, Luann Lorence of the Eagle Nest Public Library, Randall M. MacDonald, Anita "Annie" McDaniel of the Taos Historic Museums, the Rosso family, Roger Sanchez of the Raton Museum, Quentin Robinson, the Sultemeier family, the Vermejo Park Ranch, Robin Walters and David Werhane of the Philmont Scout Ranch, Thayla Wright of the Arthur Johnson Memorial Library, and Pat White of the Santa Fe Trail Museum.

A special thank-you goes to Charlotte Hollis, artist, writer, historian, and exhibit designer, for sharing digital images that she preserved in the Santa Fe Trail Museum in Springer.

INTRODUCTION

New Mexico's Colfax County is a land rich in Western romance, legend, and adventure. Many of the roads and trails traveled by modern residents and visitors are the same ones once used by a colorful cavalcade of Indians, Spanish explorers, mountain men, miners, lumbermen, and cowboys.

The boundaries of Colfax County and its county seat have changed many times in the past. In 1852, New Mexico Territory was first divided into nine counties. Taos County extended from the western side of the Rocky Mountains all the way to the New Mexico–Texas line. Seven years later, Taos County was subdivided, with the eastern part being set up as Mora County. Mora County itself was then split in 1869, with the northern half being named Colfax County—after the newly elected vice president, Schuyler Colfax. The boomtown of Elizabethtown in Moreno Valley was chosen as the first county seat, but this moved to Cimarron in 1872 and then to Springer in 1881. Colfax did not acquire its present boundaries until 1893, when the eastern portions of Colfax, Mora, and San Miguel along the New Mexico–Texas border were consolidated into Union County. Finally, in 1897, the Colfax County seat was moved permanently to Raton.

The county ranges in elevation from almost 6,000 feet on the vast grasslands in the east to the 12,441-foot Baldy Mountain that soars among the Sangre de Cristo Mountains in the west. In total, the county encompasses 3,768 square miles. Raton (elevation 6,680 feet) is the county seat and the largest town in the county, followed by Springer (elevation 5,795 feet), Cimarron (elevation 6,430 feet), and Maxwell (elevation 5,925 feet).

The first settlers in the area were American Indians. Archaeological sites found in Ponil Canyon north of the village of Cimarron indicate that many people were living in the area by AD 400. Subsisting primarily on wild food plants and game, these people later supplemented their diet by growing corn, beans, and squash along the canyon bottom. A system of flood irrigation watered the plants. These people wove intricate baskets, made cooking pots, and constructed underground pit houses in which to live. For unknown reasons, the farming people of the North Ponil abandoned the canyon around AD 1400, leaving only the remains of their houses, pots, arrow points, and baskets with which to reconstruct their culture.

Beginning in the 17th century, Jicarilla Apache Indians located campsites along the foothills and in the canyons of the area. These Native Americans rode horses to hunt buffalo. From contact with the agricultural Pueblo people of the Rio Grande Valley, they learned to grow corn and other crops to add to their primary diet of wild game. As time went on, the Jicarillas were pushed farther into the mountain canyons by Comanche and Ute Indians, their traditional enemies from the Plains.

It was in the mountains that Spaniards, the European colonizers of New Mexico, first encountered the Jicarillas. Spanish soldiers first crossed what is now Colfax County in 1706 when an expedition under Capt. Juan de Ulibarri was sent to the area in order to subdue the Comanches and protect the friendly Jicarillas. Afterward, the Spaniards referred to their land as "La Jicarilla."

Another Spanish expedition, this time led by the governor of the province, Don Antonio de Valverde, followed Ulibarri's footsteps in the summer of 1719. Although both expeditions failed to encounter any Comanches, they left the Jicarillas with promises to protect them in the future. However, the Indians were left to war and raid among themselves for the next hundred years. They saw few white people until the 1820s when French, British, and Americans arrived from the East and began exploring the Southwest.

The first Americans to enter what is now northeastern New Mexico were fur trappers who came to its mountains in search of beaver. This animal's fur was used to make stylish hats and coats worn by men in the eastern United States and in Europe.

Merchants arrived in the Southwest soon thereafter, bringing wagonloads of manufactured goods to trade in the New Mexican provincial capital of Santa Fe. Starting in Missouri, they followed the Santa Fe Trail across the plains of Kansas along the Arkansas River valley. There, the trail split, with one route taking a direct southwesterly course toward Santa Fe, while the other, known as the Mountain Branch, continued along the Arkansas River to Bent's Fort. From there, it proceeded over Raton Pass and along the eastern side of the mountains, winding its way to Santa Fe. Among the well-known mountain men and traders who passed on their way to Santa Fe or Taos were Kit Carson, Lucien Maxwell, William and Charles Bent, Ceran St. Vrain, Tom Boggs, and Dick Wootton.

Mountain man Lucien Maxwell established the first nonnative settlement in what would become Colfax County when he led settlers from Taos over the mountains to the Rayado River in 1848. He represented his father-in-law, Charles Beaubien, and Guadalupe Miranda, who had been granted land in the region by the Mexican government in 1841. He was joined there for a few years by his close friend Kit Carson. In 1857, Maxwell moved his ranch headquarters 11 miles north to the Cimarron River, where he grazed large herds of cattle and sheep and farmed extensive fields of hay, wheat, corn, and oats.

Gold was discovered in Moreno Valley in the western part of Maxwell's Ranch in 1866. Miners rushed to the goldfields in great numbers, and a town situated west of Baldy Mountain and called Elizabethtown was established the following year with a full complement of stores, restaurants, and saloons. On the east side of Baldy, a gold quartz mine called the Aztec was opened on the south side of Aztec Ridge. Maxwell was one of the mine's largest investors.

In 1870, Maxwell sold his land to foreign investors who organized as the Maxwell Land Grant & Railway Company. Whereas Maxwell had allowed settlers to raise cattle and sheep and mine gold on his ranch, the land grant company demanded that they purchase the land they occupied. Consequently, armed conflicts often arose between the settlers and the company in what became known as the Colfax County War. The question was finally resolved in 1887 when the US Supreme Court ruled in favor of the land grant company and judged that it held title to 1,714,765 acres, slightly larger than the state of Delaware.

From that point forward, settlers either bought the land they had been using or sold the improvements and livestock and moved. The company subsequently leased or sold the property primarily to large ranching operations. In addition, various coal mining and lumbering companies leased thousands of acres to pursue their enterprises.

The Santa Fe Railway entered New Mexico over Raton Pass in the fall of 1879, effectively ending 60 years of wagon freighting over the Santa Fe Trail. The railroad's track led south from the new town of Raton on the northeast side of the grant toward Las Vegas and eventually to Albuquerque. The town of Springer was established on the line 40 miles south of Raton. After the turn of the 20th century, farmers, cattlemen, and miners on the western side of the grant began to call for railroad transportation in order to market their produce, cattle, and ore. Their need was met in 1906 when the St. Louis, Rocky Mountain & Pacific Railway was built from Raton to Cimarron and through Cimarron Canyon to Ute Park.

Eventually, the Maxwell Land Grant Company sold all of its acreage, the last parcel being the 10,000-acre Baldy Mountain tract at the head of Ute Creek that was added to Philmont Scout Ranch in 1961.

One

FIRST INHABITANTS

The first permanent settlers of Colfax County were American Indians. Archaeological sites found in Ponil Canyon northwest of Cimarron and along the Vermejo River indicate that Indian people were living in the area by AD 400. Subsisting on wild food plants and game, they later supplemented their diet by growing corn, beans, and squash along the river bottoms. A system of flood irrigation watered the plants. In addition, they wove intricate baskets, made cooking pots of clay, and constructed underground pit houses in which to live.

For unknown reasons, these farming people abandoned their settlements by around AD 1400. All that is left to help archaeologists reconstruct their culture are the remains of their houses, broken pots, a lot of arrow points, and some deteriorated parts of baskets. The rock pictures, or petroglyphs, that they pecked into the canyon walls are the most visual reminder of their presence today.

Athabascan-speaking Indians entered the southwestern United States in the mid-16th century, having migrated from the far reaches of the continent over many decades. Recognized by early Spanish settlers as being Apaches and Navajos, they had completely inhabited the present states of New Mexico and Arizona by the end of the century.

The Jicarilla Apache band found a home where the mountains and the plains meet in what is now Colfax County in northeastern New Mexico. The tribe was first contacted by Spanish soldiers in 1706 and, from that point forward, allied with the Spaniards, who not only offered trade but also protection from Utes and Comanches, the Jicarillas' enemies to the east. The Jicarillas farmed corn in various canyons of the Park Plateau, a technique that they learned from Pueblo people living along the Rio Grande. They also hunted in the mountains and sometimes on the plains, where they ventured to hunt buffalo in spite of the possibility of attack by enemies.

When Lucien Maxwell established a settlement on the Rayado River, the Jicarillas resented the intrusion on their land. They frequently raided Maxwell's Ranch for cattle and horses but eventually made peace. At the beginning of the Civil War, the US government established a reservation for the Jicarillas at Maxwell's Ranch on the Cimarron River, where they stayed until they were removed to their present reservation at Dulce, New Mexico, in 1887.

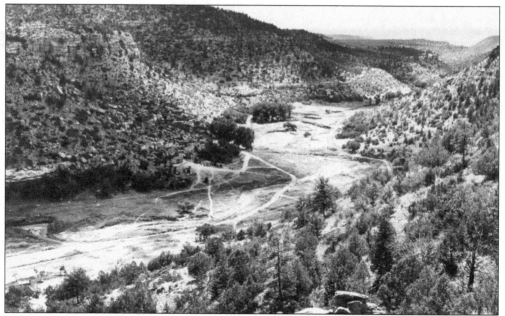

The North Ponil Canyon, located on Philmont Scout Ranch northwest of Cimarron, is a deep canyon that cuts into the Park Plateau. It was home to prehistoric Indians who inhabited it for more than 1,000 years beginning about AD 400. Rich alluvial soils, good wood supplies, and dependable water made it an optimal environment for the prehistoric farmers who lived there. (Philmont Scout Ranch.)

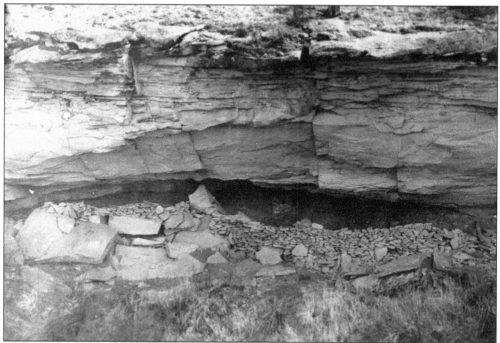

Archaeologists postulate that this rock shelter located in Box Canyon, a tributary of the North Ponil, was occupied around AD 1100–1200. Artifacts excavated at the site include pottery, arrow points, stone tools, baskets, yucca sandals, and bone beads. (Philmont Scout Ranch.)

A close look at these petroglyphs reveals the image of a left hand and forearm to the right of the "target" symbol. Archaeologists surmise that the rock pictures could symbolize anything from astronomical markers to drawings of maps that indicate trails and distances traveled. (Philmont Scout Ranch.)

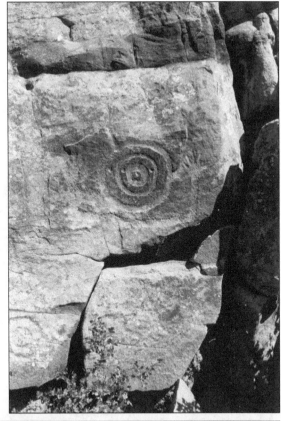

This petroglyph panel can be relatively dated because of the image of a horse that archaeologists ascribe to the horse-riding Jicarilla Apaches who inhabited North Ponil Canyon by the middle of the 17th century. (Philmont Scout Ranch.)

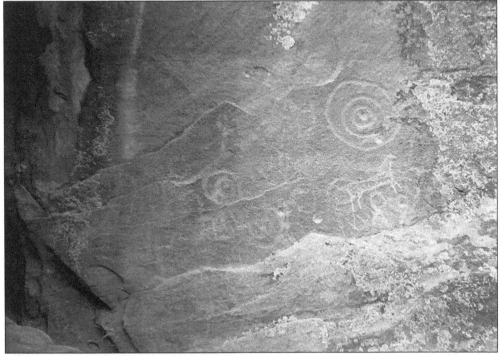

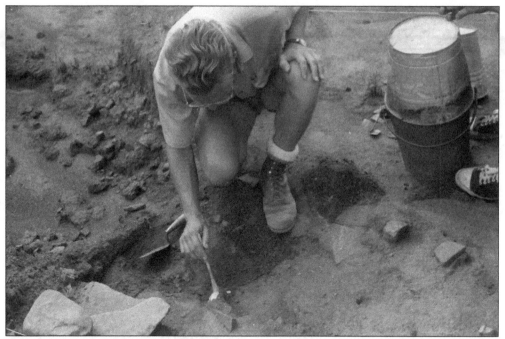

Philmont campers who visit the excavations and petroglyphs in the North Ponil Canyon learn scientific excavation techniques. Pictured here is Dr. David Kirkpatrick, who led excavation at Indian Writings Camp on Philmont in the early 1970s. (Philmont Scout Ranch.)

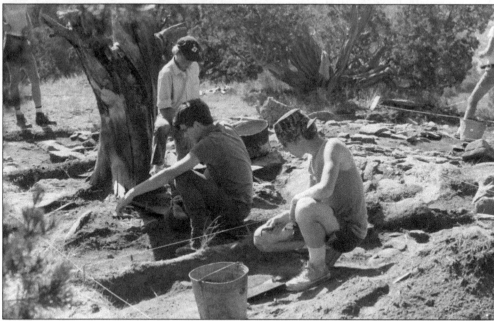

While visiting Indian Writings Camp, Philmont Scouts learn from staff members about prehistoric Indian life in the North Ponil Canyon. The Philmont Scout Ranch archaeology program began in the summer of 1957. Scouts are led by trained archaeologists who use the excavated artifacts to further their understanding of the culture of the prehistoric inhabitants who created them. (Philmont Scout Ranch.)

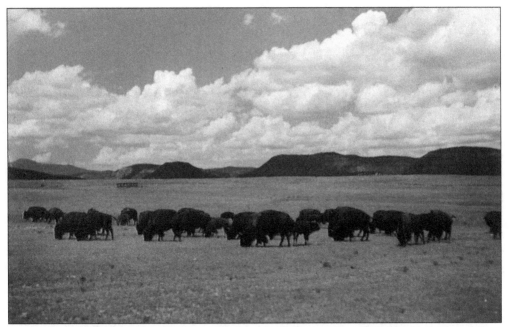

American buffalo (*Bison bison*), shown grazing on Philmont Scout Ranch, once ranged from Canada's far north down to Mexico and as far east as the Atlantic coast. Nearly extinct in the 19th century through hunting and mass slaughter, the species is making a comeback in the West through environmental as well as commercial concerns. (Randall M. MacDonald.)

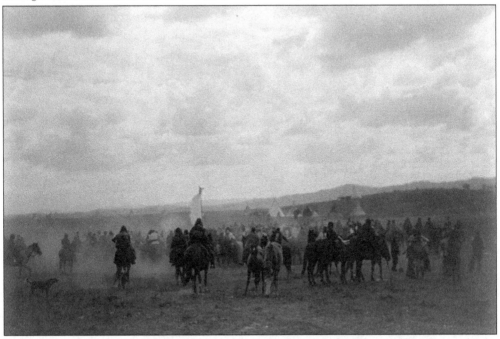

Jicarilla Apache Indians moved into the mountains and plains of what is now Colfax County by the 17th century. Anthropologists postulate that they had emigrated southward from the far northern reaches of North America. They speak the Athabascan language and are related linguistically to the Navajo Indians and other Apache groups in the Southwest. (Library of Congress.)

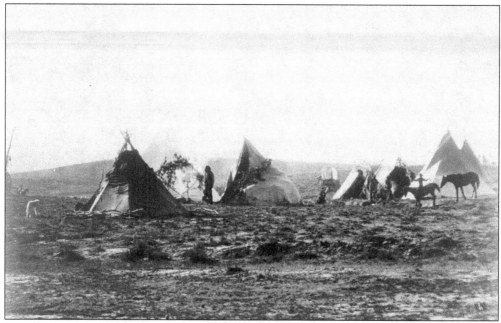

Jicarilla Apaches ranged from the Raton Mountains in the north to the area around present-day Las Vegas, New Mexico. The early Spaniards referred to this land as "La Jicarilla." This encampment was photographed about 1905 by Edward Curtis during one his many expeditions in the Southwest. (Library of Congress.)

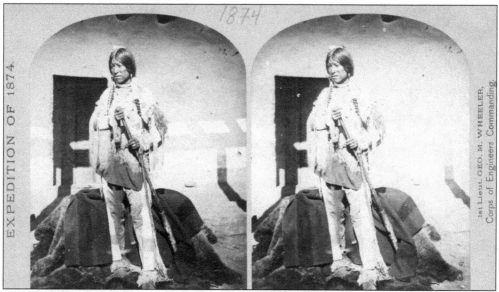

A Jicarilla warrior's primary responsibility was to hunt deer, elk, antelope, and buffalo in the mountains and on the plains. He and his fellow tribesmen also raided enemies to exact revenge for wrongs or to acquire horses. In the spring and summer, they planted and tended fields of corn near their camps in the mountain canyons. Maj. George Wheeler led a survey for the US Army that mapped New Mexico and the southwestern United States from 1872 to 1879. Photographers such as Timothy O'Sullivan joined the expedition and took hundreds of photographs of Native Americans, including this Jicarilla man in 1874. (Library of Congress.)

14

Girls of the Jicarilla tribe became of marriageable age at 16 years old. Each was destined a life of hard work that included making clothes, teepees, pots, and baskets, collecting wild food plants, and tanning skins. This Edward Curtis photograph was taken in 1904. (Library of Congress.)

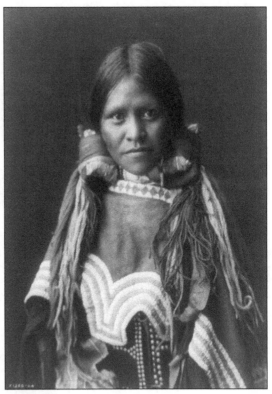

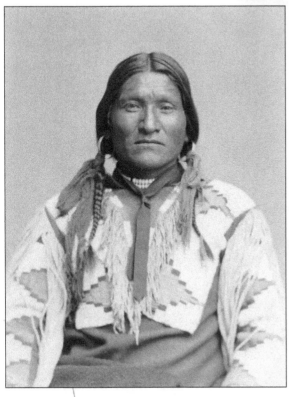

Santiago Largo (1839–1909) was an influential Jicarilla chief who led the tribe in the 1870s and 1880s. After the Supreme Court of the United States ruled in favor of the Maxwell Land Grant Company's title to 1,714,465 acres in 1887, the Jicarillas were forced west to a new reservation headquartered at Dulce, New Mexico. (Charles Milton Bell, National Anthropological Archives, Smithsonian Institution, BAE GN 2570 A.)

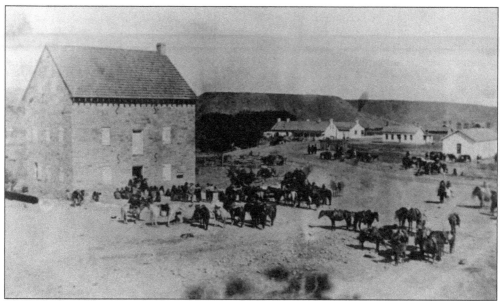

Maxwell's Ranch on the Cimarron River was reservation headquarters for more than 1,500 Jicarilla Apache and Moache Ute Indians from 1861 to 1887. The Indians received rations of ground wheat from Maxwell's Aztec gristmill built between 1860 and 1864. The view above shows blanketed Indians gathered around the mill entrance waiting for their allotments of grain. Artist Manville Chapman used this photograph to create the scene below, involving Apache Indians at Lucien Maxwell's mill in the 1860s (below). (Both, the Old Mill Museum.)

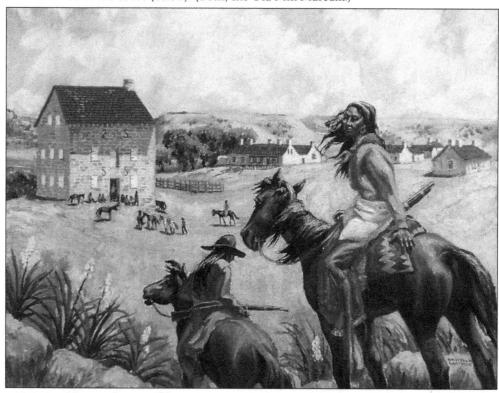

Two

FRONTIER TIMES

In 1841, a tract of land encompassing most of present-day Colfax County was granted to Mexican citizens Charles "Carlos" Beaubien and Guadalupe Miranda. Although they agreed to colonize the land, frontier conditions prevented its settlement until 1848, after the area became part of the United States as a result of the Mexican War.

In the spring of 1848, Beaubien's son-in-law Lucien Maxwell led settlers east across the mountains from Taos to the Rayado River, retracing Ulibarri's route. The colony he started was strategically located near where a trail branched off from the Santa Fe Trail to Taos over the Sangre de Cristo Range of the Rocky Mountains. Despite frequent attacks by Jicarilla Apaches, Maxwell's Ranch prospered. He pastured large herds of cattle, sheep, horses, and mules and planted hay and other crops. Kit Carson joined Maxwell as a partner in the enterprise and remained until he was appointed Indian agent for the Utes and Jicarillas in Taos in 1854.

Maxwell decided to establish a new ranch 11 miles north beside the Cimarron River in 1857. Headquartered there, he expanded operations by enlarging his cattle herds and farming extensive acreage along the river. Hundreds of men, mostly native New Mexicans, lived on his ranch, worked his fields, and herded his cattle. Sometimes, they were paid in money; at other times, they received cattle, lambs, or grain for their labor. Contemporary observers likened Maxwell's Ranch to a feudal kingdom.

Maxwell acquired Miranda's share of the grant in 1858 and, after his father-in-law died in 1864, eventually acquired the claims to the grant from the other heirs. Subsequently, the property became known as the Maxwell Land Grant. Having established a ranch kingdom of mythical proportions, Maxwell entered into negotiations to sell the grant in 1870. A group of English investors acquired the grant for $1,350,000 and established the Maxwell Land Grant & Railway Company.

The new English owners immediately encountered resistance from miners and others who had settled on the grant but did not hold clear title to their claims. The ensuing 15 years, known as the Colfax County War, was a dark period in the history of the area, postponing the granting of statehood for the territory. The region was the scene of many murders for nearly two decades after Lucien Maxwell sold the grant, and numerous conflicts arose between the new owners and miners and settlers.

Two Cimarron ministers, both of whom supported the miners and settlers, figured prominently in the conflict—one by his death and the other by his persistence. In September 1875, the Reverend F.J. Tolby, a Methodist minister and outspoken critic of the land grant company, was found dead in Cimarron Canyon, shot in the back. It was assumed by many that the killer had been hired by the company. Tolby's murder set off violence that pervaded the region for the next 15 years. Rev. Oscar P. McMains continued the crusade against the land grant company, which ended when the US Supreme Court confirmed the company the right to nearly two million acres in its decision of April 18, 1887. Peace gradually came to the region after the Supreme Court's decision. Settlers either bought their land from the company or sold their improvements and left.

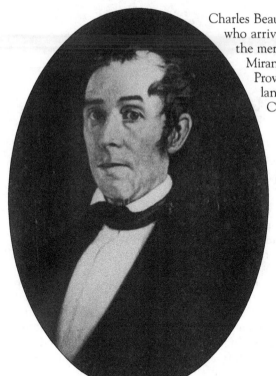

Charles Beaubien (1800–1864) was a French Canadian who arrived in Taos in the early 1820s and entered the mercantile business. Together with Guadalupe Miranda, he petitioned Gov. Manuel Armijo of the Province of New Mexico in 1841 for a grant of land that comprises much of present-day Colfax County. (Taos Historic Museums.)

Guadalupe Miranda (c. 1810–1890) was serving as secretary of state of the Mexican Province of New Mexico when he and Charles Beaubien were granted land in northeastern New Mexico by Gov. Manuel Armijo. (Arthur Johnson Memorial Library.)

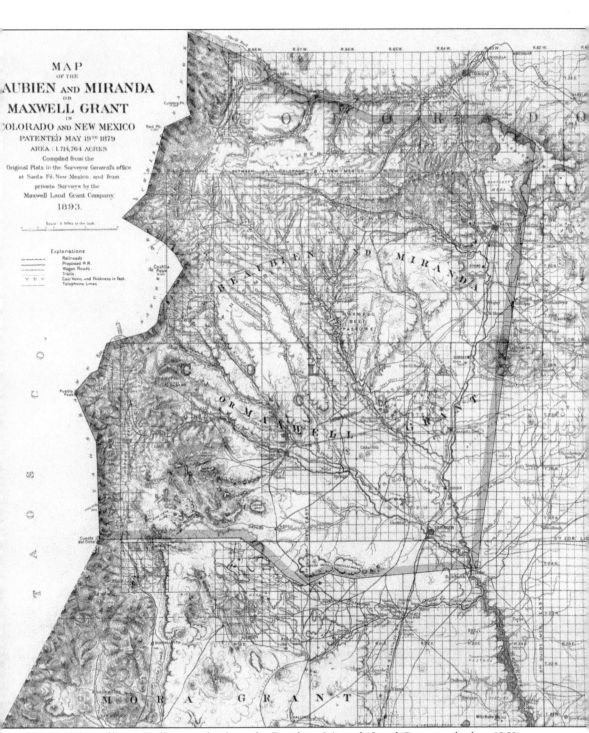

Lucien Maxwell eventually gained title to the Beaubien-Miranda Land Grant in the late 1860s. Afterward, it was referred to as the Maxwell Land Grant. He sold the 1,714,765-acre grant to English investors in 1870. (Authors' collection.)

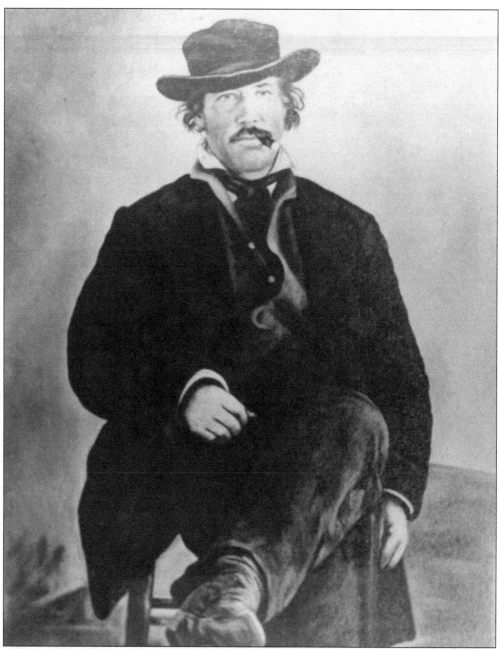

Lucien B. Maxwell (1818–1875) was born in Kaskakia, Illinois, on the Mississippi River. He first came west in 1836 to trade with Plains Indians and eventually went to Taos in the Mexican province of New Mexico. There, he worked as a trader for Charles Beaubien and married Beaubien's daughter, Luz, in 1842. Six years later, he led settlers from Taos over the mountains to the Rayado River and, along with his close friend Kit Carson, established the first settlement on the Beaubien-Miranda Land Grant. (Arthur Johnson Memorial Library.)

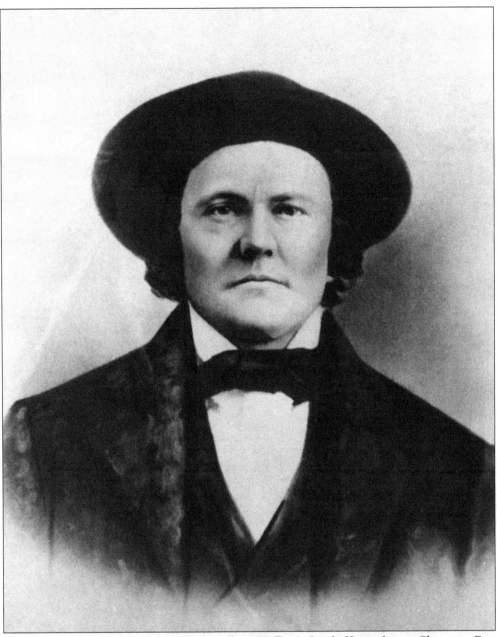

Christopher "Kit" Carson (1809–1868) was born in Tate's Creek, Kentucky, on Christmas Eve. He first came to the Mexican province of New Mexico in 1826 and settled in Taos. Three years later, he became a mountain man and, for the next decade, trapped beaver all over the American West. He and Lucien Maxwell became best friends during the time they were members of Capt. John C. Frémont's exploring expeditions of the American West in the 1840s. In 1849, Carson joined Maxwell at his Rayado settlement to help manage Beaubien and Miranda's land grant. (Arthur Johnson Memorial Library.)

This is an early view in winter of the Rayado settlement that Lucien Maxwell started in 1848 along the Santa Fe Trail. The route from Rayado went south to a crossing of the Ocate River and then to Las Vegas before it wound around the southern tip of the Rocky Mountains to the New Mexican capital of Santa Fe. (Philmont Scout Ranch.)

Kit Carson joined Lucien Maxwell at his Rayado Ranch in 1849. He states in his memoirs that "we had been leading a roving life long enough and now was the time, if ever, to make a home for ourselves and children. We were getting old and could not expect to remain any length of time able to gain a livelihood as we had been for such a number of years." At the time, Carson was 40 and Maxwell was 31. (The Old Mill Museum.)

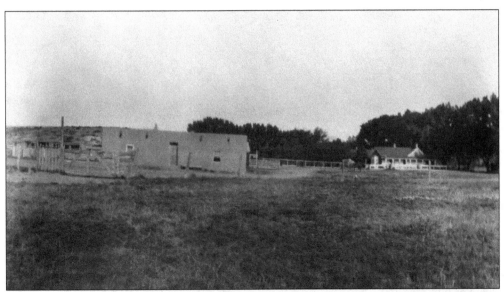

La Posta stage stop at Rayado is pictured with Maxwell's Ranch house in the background in a photograph dated around 1900. Both structures were built of adobe within a few years of each other and feature the same squared-off ceiling beams, or vigas, typical of Southwestern architecture. (Philmont Scout Ranch.)

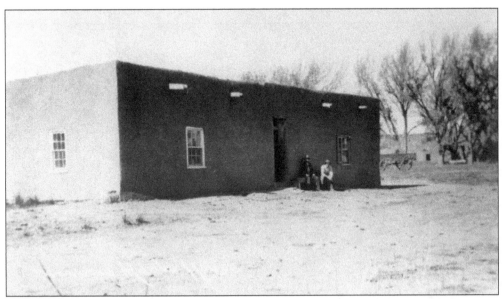

The US mail stage stopped at Rayado and picked up fresh horses at La Posta. Passengers were able to briefly step off the coach and take advantage of a quick meal while the new team was being hitched up. Today, Rayado is an interpretive museum run by the Philmont Scout Ranch and open to visitors. (Philmont Scout Ranch.)

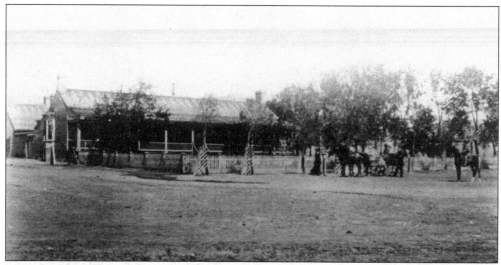

In 1857, Lucien Maxwell moved his ranch operation north from Rayado to the Cimarron River, where he built this house on the south side of the river. Here, he welcomed new and old friends and treated them liberally, with gambling in the building just to the left of the main house being a nightly diversion. (Arthur Johnson Memorial Library.)

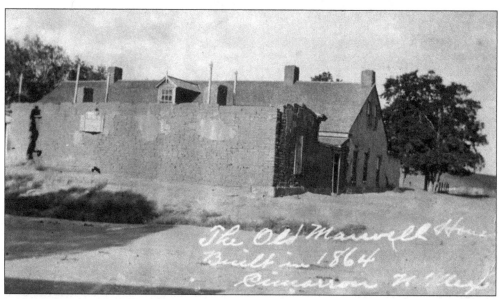

Maxwell's house is pictured after he had sold the land grant and departed his ranch on the Cimarron. For a time, the new owners used the house, but it eventually fell into disrepair. The house burned down several times, with the last fire being surrounded in mystery in 1922. (Randall M. MacDonald.)

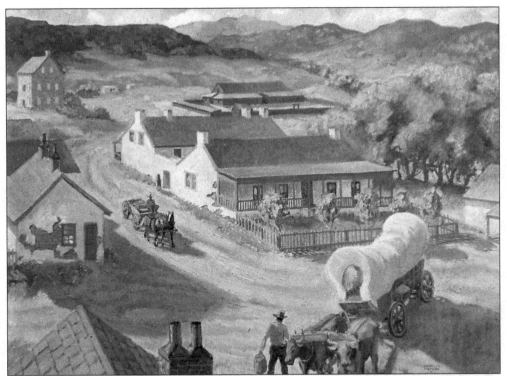

Raton artist Manville Chapman (1903–1978) painted this rendition (shown here in black and white) of Maxwell's Ranch on the Cimarron River as it may have looked in the 1860s. The wagon illustrated here is typical of the Conestoga wagon, originally produced in Pennsylvania and later exported to others states as westward expansion grew. However, construction of the curved body of the Conestoga was labor intensive, so by the mid-1850s a simpler, straighter design commonly known as a Santa Fe wagon was more popular. (The Old Mill Museum.)

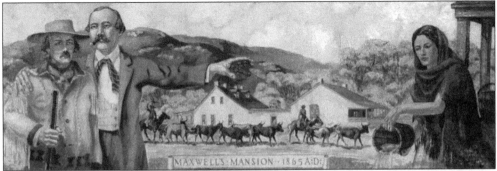

In the 1930s, Raton artist Manville Chapman depicted Lucien Maxwell with his friend Kit Carson in front of Maxwell's house. This and seven other murals are located in the lobby of the Shuler Theater in Raton. (Authors' collection.)

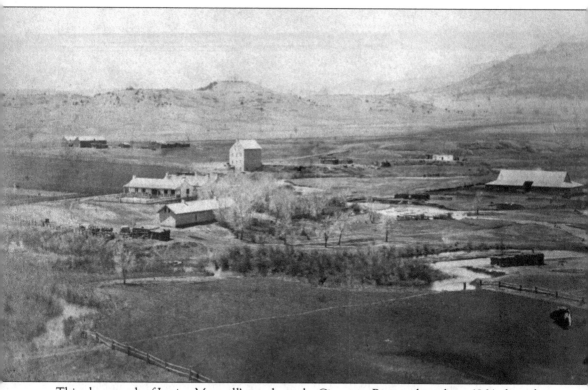

This photograph of Lucien Maxwell's ranch on the Cimarron River, taken about 1864, shows his home in the middle left, with John and Andres Dold's warehouse in front. Maxwell's new four-story gristmill is in the distance and his stables are at the right. This is the earliest known image of the ranch. (Southern Methodist University.)

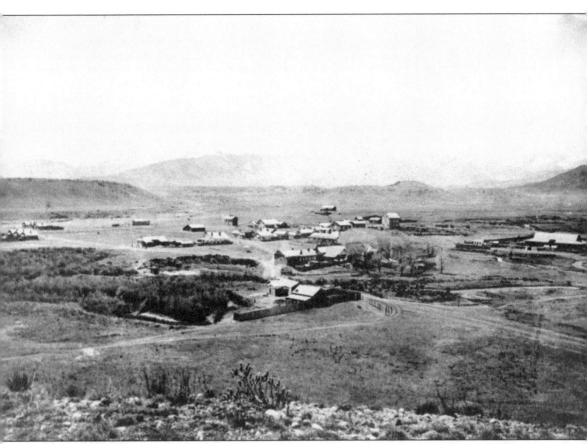

A decade later, Cimarron had grown from a sleepy stop on the Santa Fe Trail into a thriving village. This picture was taken from the same vantage point as the photograph on the opposite page but after English investors had purchased Maxwell's land in 1870 and formed the Maxwell Land Grant & Railway Company. Maxwell's gristmill stands proudly in the distance close to the meandering Cimarron River, which fed its waterwheel. A church rests near the hill; on the left in front of it is the cluster of houses built for the land grant managers. To their right is the broad peaked roof of the new jail, situated by itself. The Santa Fe Trail passes by the house in the foreground and goes past the plaza well and toward the church before winding around the hill and heading south toward Rayado and Santa Fe. (The Old Mill Museum.)

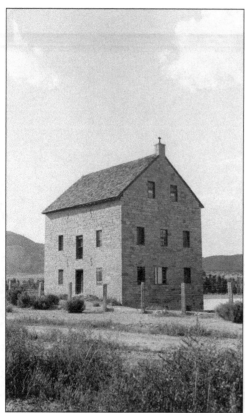

Maxwell built this stone gristmill west of his house in the early 1860s. Construction was based on the four-story design by easterner Oliver Evans and took four years to complete. Operated by millers who diverted water from the Cimarron River, the Aztec Mill provided ground flour not only for employees of Maxwell's Ranch but also for government soldiers and Apache and Ute Indians who lived nearby. (The Old Mill Museum.)

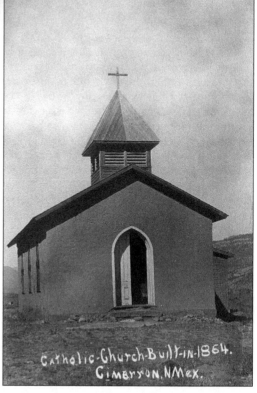

This Catholic church was built of adobe at Maxwell's Ranch in 1864. The pastor there met the religious needs of not only Maxwell's employees but also people who visited the ranch on their travels north or south along the Santa Fe Trail. (Randall M. MacDonald.)

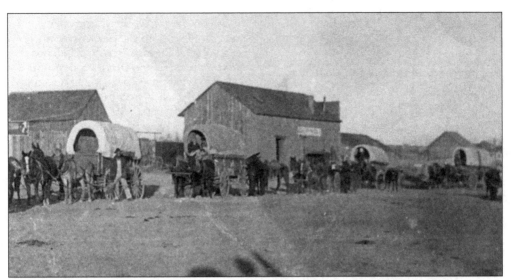

Freight wagons like these hauled goods from the east over 7,800-foot Raton Pass and past Cimarron and Rayado from the time the towns were founded until 1880. Their ultimate destination was the New Mexico Territorial capital of Santa Fe. The route they traveled was known as the Mountain Branch of the Santa Fe Trail. After 1880, goods were transported east and west via railroad. (Santa Fe Trail Museum.)

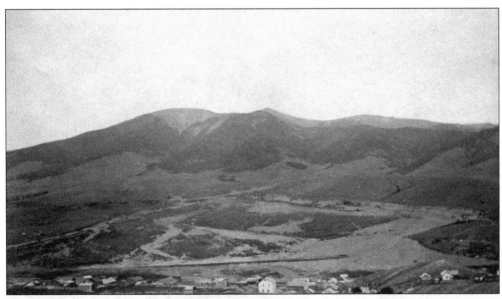

The western summit of Baldy Mountain, the highest point in Colfax County at over 12,000 feet, is seen from Moreno Valley along with what remains of the gold-mining boomtown of Elizabethtown. Gold flakes and nuggets eroded out of the mountain over eons of time and were deposited in the numerous creeks and gulches below. (Library of Congress.)

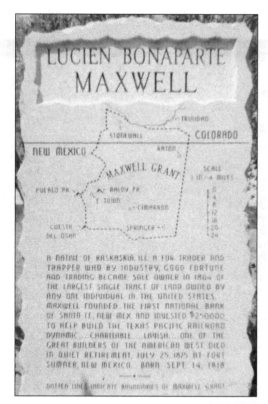

In 1870, Maxwell left the Cimarron area and moved south to the Pecos River where he purchased the buildings of abandoned Fort Sumner, ranching until his death in 1875. He is buried at Fort Sumner next to New Mexico's most famous (or infamous) outlaw, Billy the Kid, who was killed in the house of Maxwell's son, Peter, in 1881. (Arthur Johnson Memorial Library.)

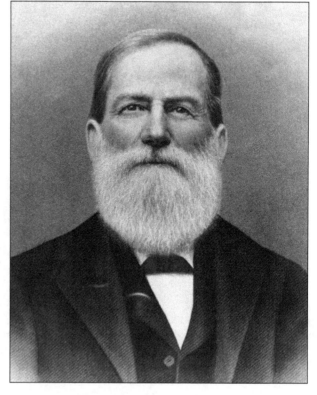

Jesus Abreu (1823–1900) came to Maxwell's Rayado Ranch in the early 1850s with his wife, Petra, who was Charles Beaubien's daughter and Luz Maxwell's sister. Abreu acquired the Rayado Ranch after Maxwell had moved north to the Cimarron River in 1857. Until his death, Abreu produced high-quality sheep, cattle, and horses that were highly praised throughout the Southwest. (Philmont Scout Ranch.)

The Abreu family is pictured on the east side of their newly remodeled home on Rayado Ranch around 1910. It was originally constructed with a flat roof in the 1850s, but Jesus Abreu's sons erected a pitched roof on the house in the first decade of the 20th century. In this photograph, Petra Abreu (1844–1914) is seated, surrounded by her sons and daughters. (Philmont Scout Ranch.)

Petra Abreu had this family chapel built directly east of her house at Rayado in 1902 in memory of her husband, Jesus. After she passed away, the Holy Child Chapel was deeded to the Archdiocese of Santa Fe and has occasionally been used for marriage ceremonies. (Arthur Johnson Memorial Library.)

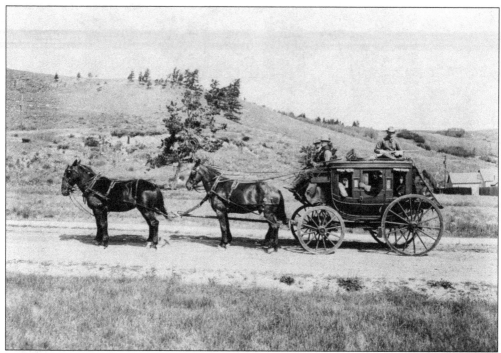

Mail and passenger traffic began over the mountain branch of the Santa Fe Trail in 1861. After crossing Raton Pass, stagecoaches drove southwestward along the foot of the mountains, making stops at Cimarron and Rayado. Heavy-duty coaches, referred to as mud wagons, were usually drawn with teams of six horses. (Library of Congress.)

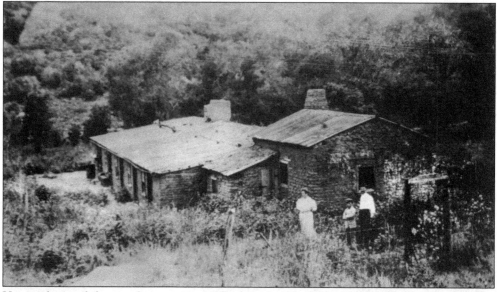

Here is the ranch house of mountain man Richens L. "Uncle Dick" Wootton (1816–1893), who built a 27-mile toll road over Raton Pass in 1866, charging "two bits" per horse and "a buck and a half" per wagon. The road made for easier travel over the rough mountains for Santa Fe traders. Later, Wootton sold the road to the Santa Fe Railway, which used much of it for laying tracks across the pass into New Mexico in 1878. (Santa Fe Trail Museum.)

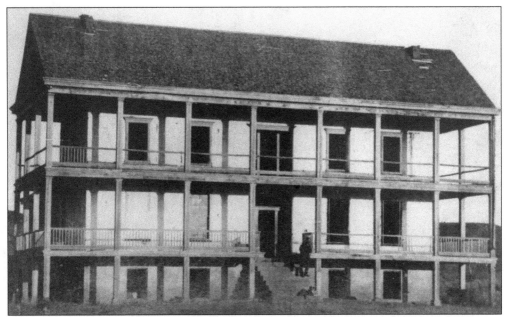

Rancher Tom Stockton built this roadhouse, called the Clifton House, on the Canadian River in 1867. Also known as the Red River Hotel (after the original name of the river), it was a stopover for trail stagecoaches and drovers driving Texas cattle north over Raton Pass. Later, it was sold to the Barlow & Sanderson Overland Mail Company, which had the mail and passenger contract along the Santa Fe Trail. (Santa Fe Trail Museum.)

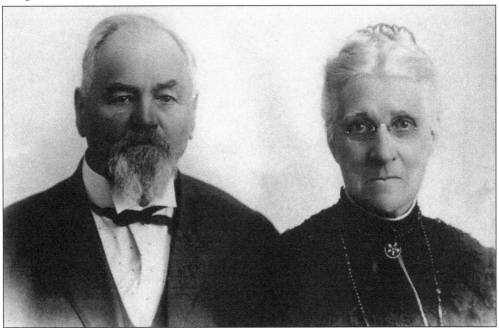

John B. Dawson (1830–1918), pictured with his wife, Lavinia (1841–1923), drove cattle through northeastern New Mexico with partners Charles Goodnight and Oliver Loving in the late 1860s. In January 1869, he bought 3,700 acres from Lucien Maxwell to start a ranch on the Vermejo River, later expanding it to over 24,000 acres. (The Old Mill Museum.)

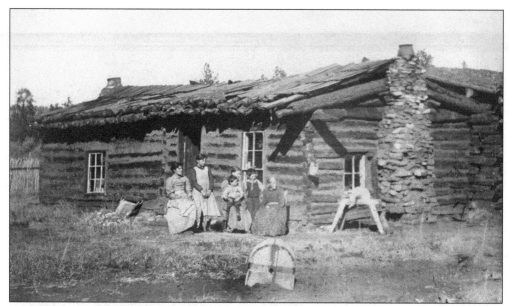

Pioneer homestead families, like this one pictured in front of their spacious log cabin on the Maxwell Land Grant, would have lived by farming vegetables and hay; raising cattle, pigs, and chickens; and hunting and fishing. (The Old Mill Museum.)

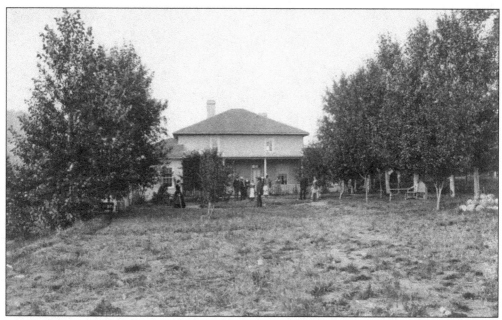

Manly Chase built this house on his ranch on the Ponil River in the 1870s. Along with his own ranch, Chase managed the Maxwell Cattle Company on the grant in the 1880s and 1890s. After an exhaustive cattle drive to Texas in 1879, Chase arrived home to find that his wife, Teresa, had used all the remaining ranch hands to add a second story to their home. (The Old Mill Museum.)

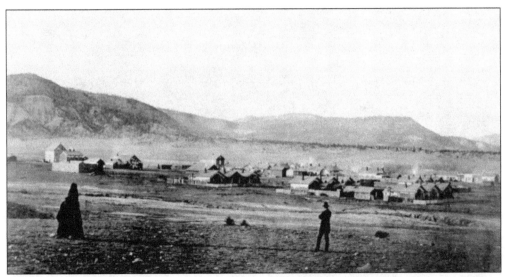

Cimarron was the headquarters of the Maxwell Land Grant Company in the 1870s and 1880s. In this late 19th-century view looking northwest, three rows of land grant managers' houses can be seen in the front right of the photograph with the gristmill at the far left. (The Old Mill Museum.)

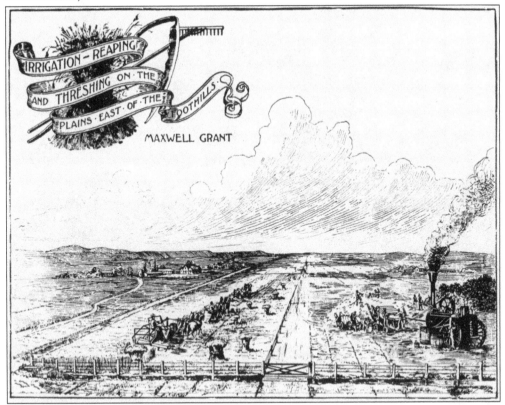

The Maxwell Land Grant Company used illustrations such as this in brochures to promote the sale of farmland in the 1880s. Other ads highlighted opportunities in the coal, lumber, gold, and livestock industries. (Philmont Scout Ranch.)

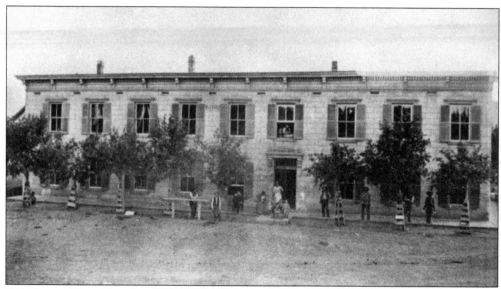

Frenchman Henry Lambert (1838–1913) acquired a small saloon in Cimarron in 1872 after running a hotel in the gold-mining town of Elizabethtown in Moreno Valley. By 1880, Lambert had added the second wing and story shown here to what became known as the St. James Hotel. (Arthur Johnson Memorial Library.)

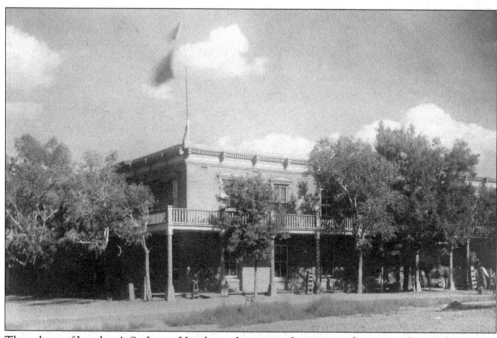

The saloon of Lambert's St. James Hotel was the scene of numerous shoot-outs during the Colfax County War, an infamous conflict between miners and settlers over land rights with the Maxwell Land Grant Company in the 1870s and 1880s. The conflict only ended after Pres. Rutherford Hayes removed corrupt Samuel Axtell as governor of New Mexico Territory and temporarily appointed Gen. Lew Wallace. (The Old Mill Museum.)

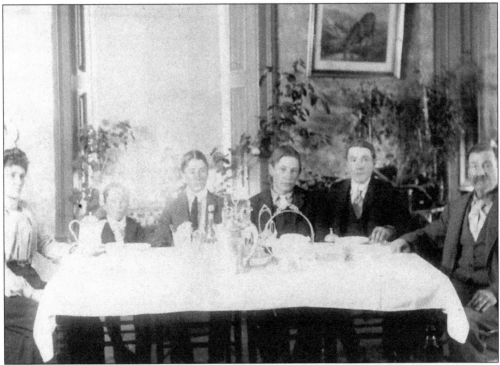

Henry Lambert, his wife, Mary (1858–1926), and four of their five sons are pictured in the dining room of the St. James Hotel during the early 1890s. Lambert reputedly served as chef for Pres. Abraham Lincoln before he moved west to the goldfields of Moreno Valley. (Lambert family.)

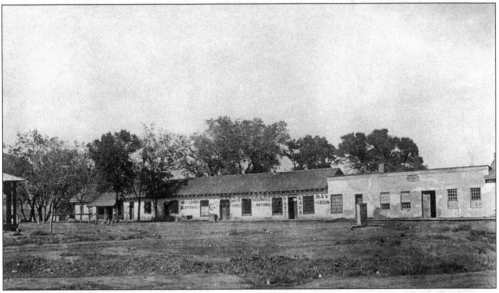

Henry B. Porter established a mercantile in Cimarron in the 1870s. He also grazed cattle on extensive rangeland southeast of the town. The building on the left was the warehouse for John and Andres Dold's freight hauling business (see page 13) to which Porter added the building on the right. Part of the roof over the plaza well can be seen to the left, with the Santa Fe Trail in the immediate foreground. (The Old Mill Museum.)

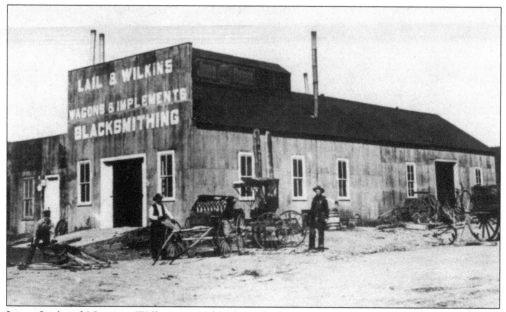

James Lail and Norman Wilkins ran a blacksmith shop in Cimarron where they shod horses, repaired wagons, and sold farm equipment. This building was constructed of metal-clad adobe bricks shortly after the railroad arrived in 1906. It was later converted into a movie theater until it collapsed in the 1980s. (The Old Mill Museum.)

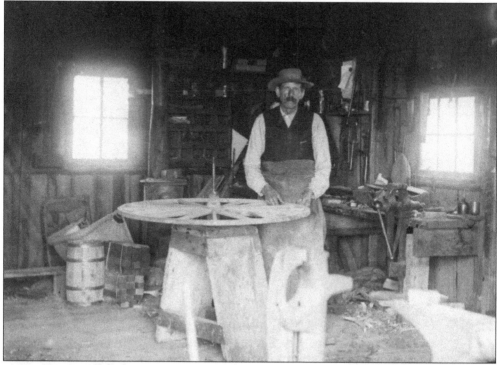

Blacksmith A.C. Hoover is pictured here working on a wagon wheel at his shop in Cimarron. Blacksmiths were indispensable for the work they performed in frontier towns of the West during the horse-drawn and riding days. (The Old Mill Museum.)

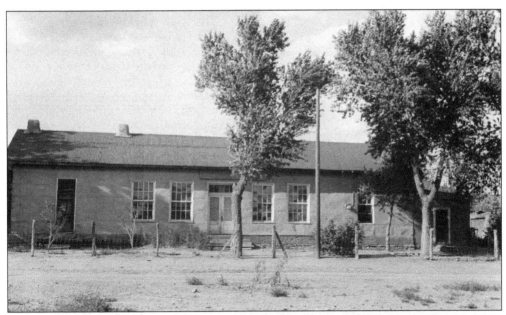

The seat of Colfax County was moved from Elizabethtown to Cimarron in 1872 when this courthouse was built. Today, it serves as the home of the local Masonic lodge after having been used as a school and residence. (The Old Mill Museum.)

Robert Clay Allison (1840–1887) was a Cimarron rancher who came to fame during the turbulent days of the Colfax County War. The quintessential good-bad man, Allison championed the rights of settlers against the Maxwell Land Grant Company. It was rumored that he was involved in the lynching murder of Cruz Vega, who was a person of interest in the murder of the Reverend Tolby. Allison's later shooting of Francisco "Pancho" Griego in Lambert's saloon was ruled justifiable homicide. (Taos Historic Museums.)

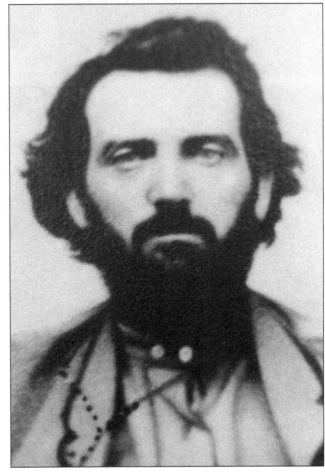

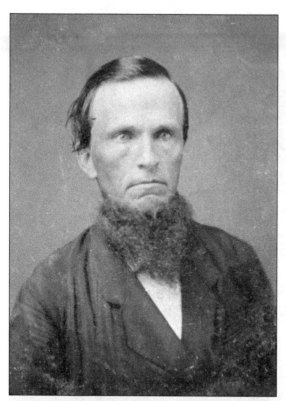

This is the only known image of Rev. Franklin J. Tolby (1841–1875), the Methodist circuit minister who championed the rights of settlers and miners against the Maxwell Land Grant Company. Tolby was murdered in September 1875 while riding in the canyon between Cimarron and Elizabethtown. Many people at the time suspected that the land grant company had hired someone to silence one of its most vocal and influential critics. (Quentin Robinson.)

Oscar P. McMains (1840–1899) was the Methodist minister who took up the campaign for settlers' rights against the Maxwell Land Grant Company after Reverend Tolby's murder. McMains was indicted in 1877 for the lynching of Cruz Vega during the Colfax County War but was found guilty only of "murder in the fifth degree." The resulting fine of $300 was left unpaid as a new trial was later dismissed for lack of evidence. (The Old Mill Museum.)

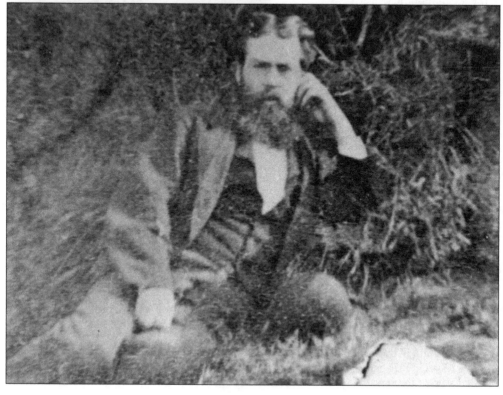

Three

RANCHING

When Lucien Maxwell established a ranch on the Rayado River in 1848, he grazed not only beef cattle but also oxen, which he bartered to traders hauling freight from the United States to the New Mexican territorial capital of Santa Fe. After he moved his ranch north to the Cimarron River in 1857, his brother-in-law Jesus Abreu took over on the Rayado and raised high-quality sheep, cattle, and horses there for the rest of the century.

On the Cimarron, Maxwell increased his herds in order to supply beef to the Jicarilla Apaches whose reservation was headquartered at the ranch. Later, in the 1860s, Maxwell sold ranchland from the grant to Manly Chase in Ponil Canyon and John B. Dawson on the Vermejo River. Once the Maxwell Land Grant Company took over, it sold several parcels of land for cattle grazing, the most prominent piece going to the company's legal counsel, Frank Springer, who partnered with his brother Charles to establish the CS Cattle Company. The ranch is still in operation today under family descendants.

The arrival of the Santa Fe Railway into New Mexico in 1879 created a shipping avenue for ranchers to beef markets in the Midwest and farther east. Soon, Texas cattlemen began driving cattle onto the rich open-range grasslands of northeastern New Mexico Territory. The land grant company entered the cattle business in 1881 when it formed a subsidiary, the Maxwell Cattle Company, to handle herds on more than one million acres of the grant. By the middle of the decade, it was estimated that 100,000 head of cattle owned by a number of stock raisers grazed Colfax County.

The Maxwell Cattle Company ceased operation in 1892 when the land grant company chose to sell land for grazing purposes rather than run cattle itself. At the turn of the century, William Bartlett, a Chicago grain trader, purchased a large parcel of the grant along the Vermejo River and started Vermejo Park Ranch. In the early 1920s, Oklahoma oilman Waite Phillips consolidated several ranch properties on the grant outside of Cimarron to form Philmont Ranch, which eventually encompassed more than 300,000 acres.

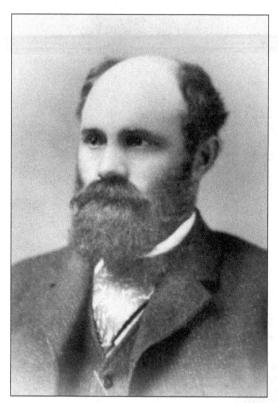

Manly Chase (1842–1915) came to Lucien Maxwell's grant in 1867 and settled on the Vermejo River. Two years later, he traded a herd of range horses to Maxwell for 1,000 acres along the Ponil River northwest of Cimarron. In 1871, Chase moved with his wife, Theresa, to the Ponil River, where they began building the adobe house that still stands at present-day Chase Ranch headquarters (see page 34). The historic home is now a museum operated by the Philmont Scout Ranch and open to the public. (Arthur Johnson Memorial Library.)

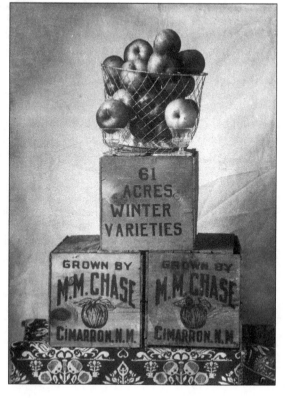

In the second half of the 19th century, Colfax County proved to provide an ideal climate for growing fruit, especially apples. Manly Chase was one of the leaders in the effort, which doubters referred to as Chase's Folly, at his ranch in Ponil Canyon. Other growers of note were George Webster on Cimarroncito Creek and Jesus Abreu at his ranch on the Rayado River. (The Old Mill Museum.)

George Mason Chase
(1870–1943), the son of Manly
and Theresa Chase, married
Henrietta "Nettie" Curtis
(1879–1927) in 1895. Five years
later, when the elder Mrs.
Chase passed away, Nettie
took over running the house
on the ranch. She was an
accomplished horsewoman and,
along with helping with the
cow work, enjoyed hunting in
the mountains on horseback.
(Philmont Museum.)

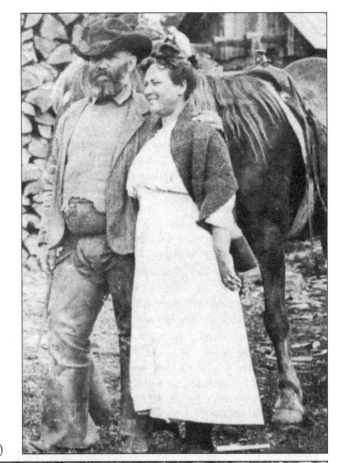

Here, Mason (holding child)
and Nettie Chase (right) are
shown with friends in their
famous apple orchard at Chase
Ranch. (The Old Mill Museum.)

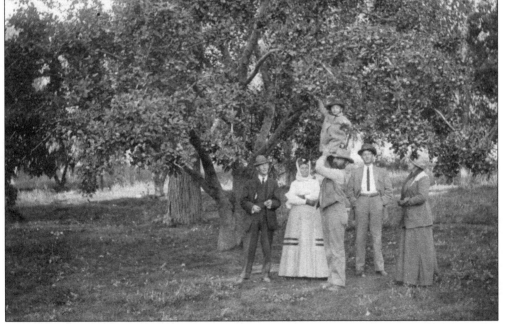

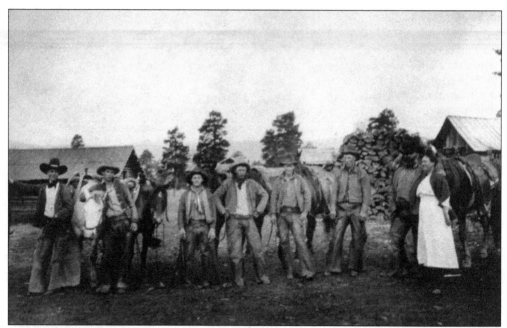

Mason and his brother Stanley began managing Chase Ranch after their father died. Mason is pictured here at right with some of his cowboys at Ring Place in the North Ponil Canyon. Shorty Murray (1897–1993) is on the left. Even though of short stature, Murray was always known to wear the biggest hat and spurs of all of the cowboys. (Santa Fe Trail Museum.)

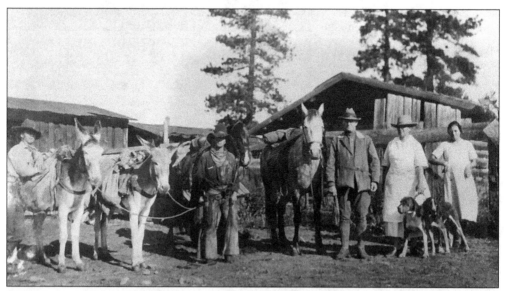

This group pictured around 1924 on the Chase Ranch is preparing for a pack trip into the mountains. Shorty Murray is in the center carrying his ever-present six-shooter. When he worked for the Chase Ranch in the 1920s, Murray periodically got off his horse while herding cattle in the North Ponil Canyon and pecked his name on the sandstone rocks. Several examples of these modern petroglyphs can still be seen on canyon walls. (Philmont Museum.)

Gretchen Sammis (1925–2012), Manly and Theresa Chase's great-granddaughter, gained ownership of the Chase Ranch in the 1940s. For many years, she taught at Cimarron High School, but in the early 1960s, she started running the ranch full-time. Before she passed away, she was honored by the New Mexico Cattle Growers as Cattleman of the Year and was also inducted into the National Cowgirl Hall of Fame. (Philmont Museum.)

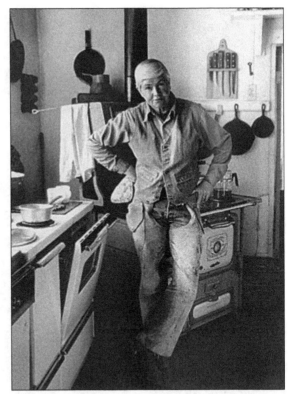

Gretchen Sammis (left) and her foreman, Ruby Gobble (1931–2013), who was also inducted into the Cowgirl Hall of Fame, were partners running the Chase Ranch in Ponil Canyon for 45 years. They did everything on the ranch from herding cattle to irrigating hayfields and running heavy equipment. One of the few times they had outside help was when they branded calves in the spring. (Philmont Museum.)

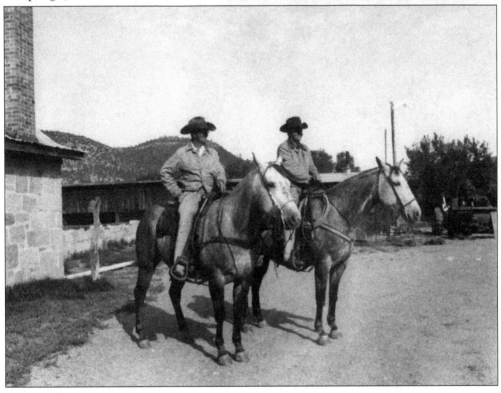

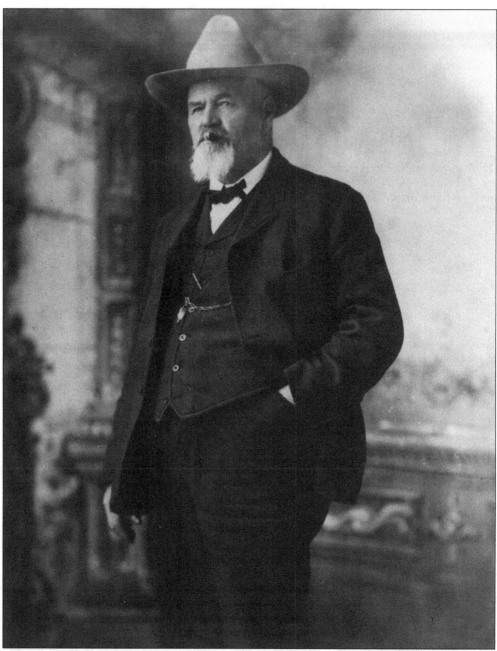

John B. Dawson first drove cattle through northeastern New Mexico when he guided West Texas ranchers Charles Goodnight and Oliver Loving over a safer route to beef markets in Colorado and Wyoming in 1866. Three years later, Dawson bought land from Lucien Maxwell to start a ranch on the Vermejo River. After discovering coal on his land and providing it to neighboring ranchers, the Maxwell Land Grant Company, which hoped to sell coal to the railroad, sued him in the US Supreme Court. Dawson won the suit and, in 1901, sold his land to the Dawson Fuel Company, moving to Colorado where he happened again upon large coal deposits. He and his wife, Lavinia, later retired to Los Angeles, California, where they are buried. (Santa Fe Trail Museum.)

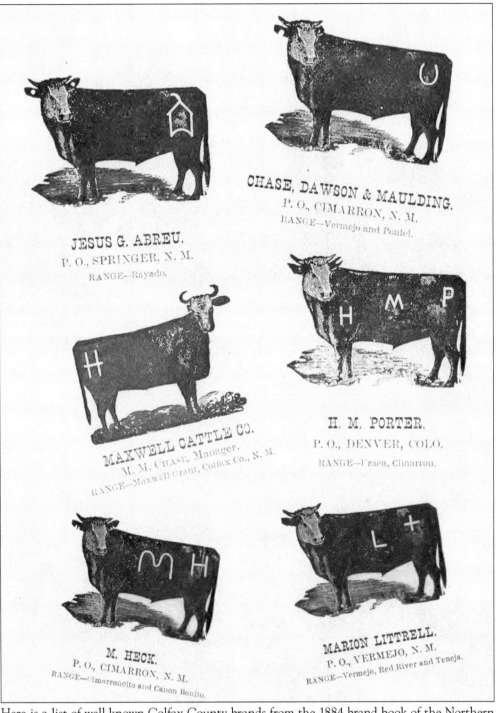

JESUS G. ABREU.
P. O., SPRINGER, N. M.
RANGE—Rayado.

CHASE, DAWSON & MAULDING.
P. O., CIMARRON, N. M.
RANGE—Vermejo and Poniel.

MAXWELL CATTLE CO.
M. M. CHASE, Manager.
RANGE—Maxwell Grant, Colfax Co., N. M.

H. M. PORTER.
P. O., DENVER, COLO.
RANGE—Uraca, Cimarron.

M. HECK.
P. O., CIMARRON, N. M.
RANGE—Cimarroncito and Canon Bonito.

MARION LITTRELL.
P. O., VERMEJO, N. M.
RANGE—Vermejo, Red River and Teneja.

Here is a list of well-known Colfax County brands from the 1884 brand book of the Northern New Mexico Stock Growers' Association. (Authors' collection.)

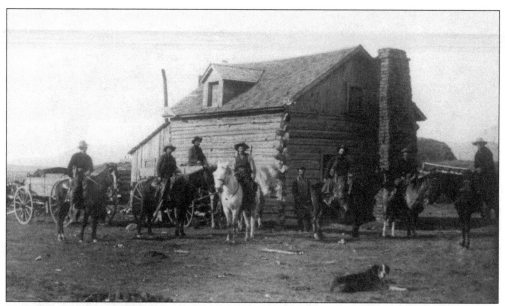

The Maxwell Land Grant Company established a subsidiary stock-raising venture in 1881 in order to graze the immense grasslands of the grant. The company's cattle were branded with the Long H brand, which was on cattle they had purchased from Lonny Horn. These Maxwell cowboys are in front of the Crow Creek Camp; the cabin still stands at the Crow Creek Ranch headquarters on the CS Ranch. (The Old Mill Museum.)

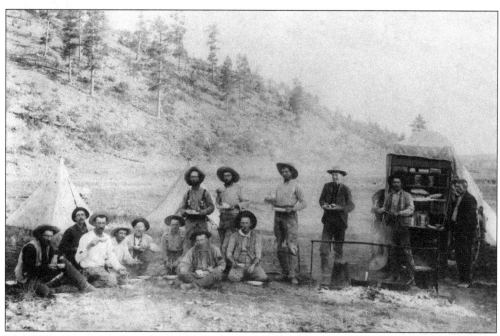

This 1892 photograph shows Maxwell Cattle Company cowboys including, from left to right, cow boss Marion Littrell, Frank Stubblefield, George Rutherford, Billie Whiteman, Jack Codlin, Jack Fanning, Tom South, Henry Muldrow, Tim Parish, Jeff England, Hugh England, Jim Gillespie, Frank Shoemaker, and wagon cook Tom Finian. (The Old Mill Museum.)

Attorney Frank Springer (1848–1927) arrived in Colfax County from Iowa in 1873 to become legal counsel for the Maxwell Land Grant Company. Soon afterward, he bought 18,000 acres of rangeland along the Cimarron River from the company. In 1878, he was joined by his brother, Charles, and together they expanded their holdings, forming the Charles Springer Cattle Company. In addition to being a lawyer for the land grant company and helping his brother on the ranch, Frank was also a noted expert on crinoid fossils and helped establish New Mexico Normal University (renamed New Mexico Highlands University). (The Old Mill Museum.)

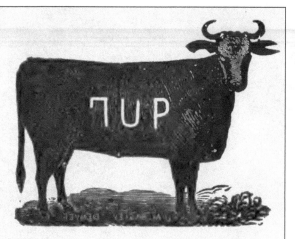

CHARLES SPRINGER.

P. O., CIMARRON, N. M.

RANGE—Cimarron and Uracca Rivers.

ADDITIONAL BRANDS.

Thoroughbred Stock, **CS** on right side.

Some stock branded **B BX** right hip and side.

HORSE BRAND, **CS** on right shoulder.

Through the CS Cattle Company, Frank and Charles Springer imported the first purebred Hereford bulls into Colfax County in 1881. According to the *Colfax County Brand Book* from 1884, thoroughbred cattle were branded on the right side with a CS and commercial cattle with a 7UP. Descendants of the Springer brothers still run the ranch today. (Authors' collection.)

In 1918, Charles Springer built a dam across the Cimarron River to form the reservoir called Eagle Nest Lake. This alleviated the flash flooding that often occurred along the Cimarron Valley in times of heavy rainfall or rapid snowpack melt and also provided irrigation water to the farmers and ranchers downstream. (Randall M. MacDonald.)

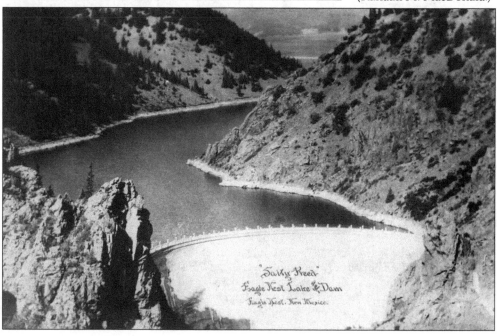

"Salty Reed"
Eagle Nest Lake & Dam
Eagle Nest, New Mexico.

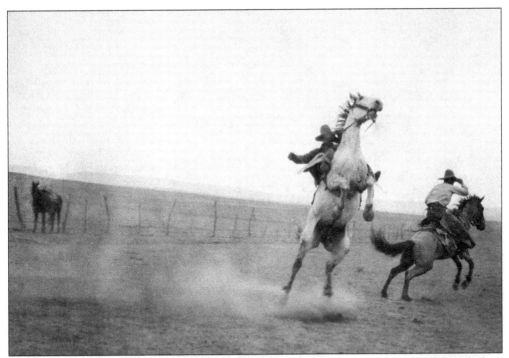

These CS cowboys, photographed in the 1930s, appear to be having some difficulty with their horses. Each cowboy on the ranch at the time would have eight to ten head in his string of horses, some that were older veterans and several young ones that needed a lot of riding and training. (Sultemeier family.)

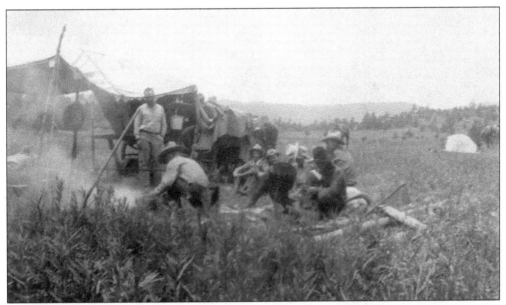

As late as the 1930s and 1940s, CS Ranch cowboys camped each night with a chuck wagon during the spring and fall works. A cook using cast-iron Dutch ovens and skillets prepared filling meals over an open campfire. The fare always included some form of beef along with beans and biscuits. If the cowboys were lucky, the cook would bake them a dried-apple pie. (Authors' collection.)

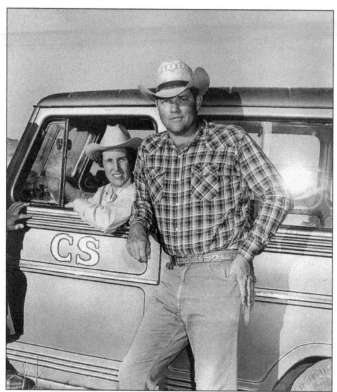

James Leslie Davis (1919–2001) married Linda Mitchell in 1953. Les's grandfather was Frank Springer, who, along with his brother Charles, started the CS Ranch. Linda's father was Albert Mitchell, who managed the Bell Ranch along with his own cattle operation in San Miguel County. After graduating from Dartmouth College in 1941 and earning numerous medals in World War II, Les moved to the CS to work with his uncle Edward, who managed the ranch. Today, Les and Linda's six children and numerous grandchildren operate the ranch. (The Old Mill Museum.)

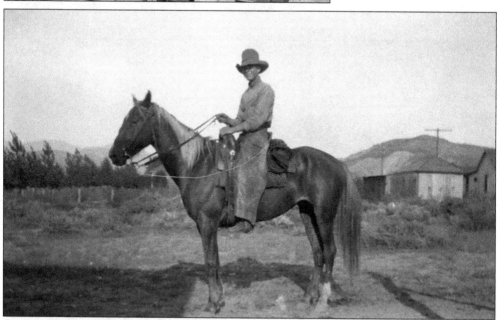

Tommy Rupert, who married Manly Chase's granddaughter, Margaret, was typical of the cowpunchers who worked on ranches in Colfax County before World War II. All were known to be capable ropers as well as good bronco riders. Even though a lot of ranches in the American West mechanized soon after the war, the majority of those in Colfax County remained horseback outfits because of the rough terrain. (Philmont Museum.)

Jiggs E. Porter (1916–2005), pictured on the left in this 1983 photograph, became cow foreman of the CS Ranch in 1947 after service in the US Army in World War II. On the right is Shorty Murray, who worked for many Colfax County ranches in a long and storied cowboy career. The two probably knew the mountains and canyons of the county more intimately than anyone else from their time having worked most of it on horseback. (Authors' collection.)

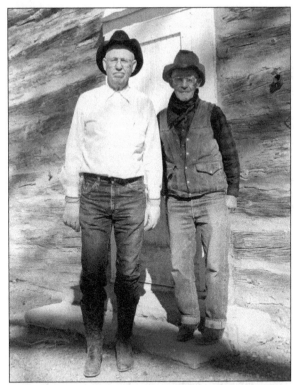

The band of cowboys' saddle horses, known as a remuda, was gathered, or jingled, every morning before breakfast. After both cowboys and horses were fed, one man roped out the mounts that each cowboy had selected for the morning's work. Here, CS Ranch foreman Jiggs Porter is roping horses out of the remuda using a houlihan throw at Crow Creek. (Authors' collection.)

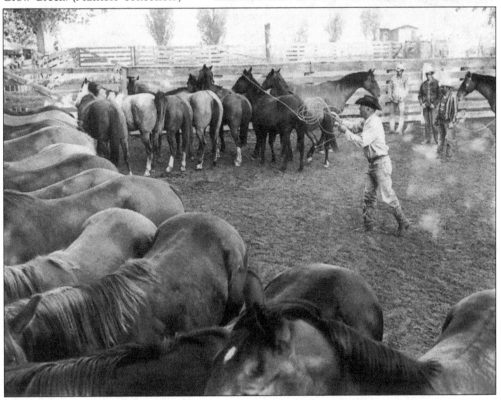

Jiggs Porter (left and below) first hired on to the CS Ranch in June 1933. He worked on the ranch for the rest of his life except for the four years he spent, as he said, "working for Mr. Roosevelt" in World War II. During his 63 years with the CS, Jiggs was known for his knowledge of cattle and horses and their breeding and has transferred that knowledge to the six Davis children who have followed in their parents' footsteps. (Both, authors' collection.)

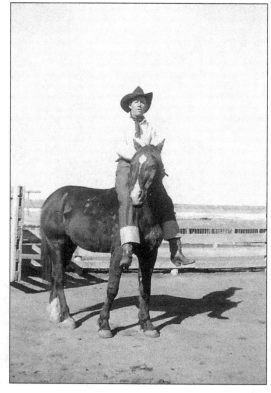

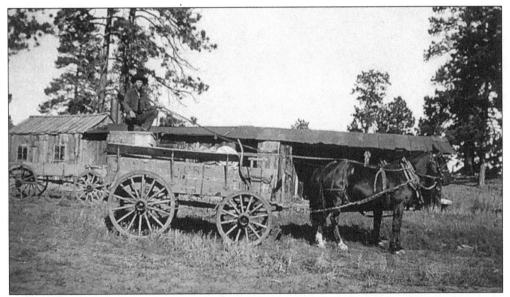

CS Ranch cowboy Jiggs Porter is pictured here at the reins of a wagon in 1935. Wagon teams were also "broke to saddle" in case the cowboys needed to ride them. In a 1985 interview, Porter remembered that he bought the last two wagons for the ranch, which were delivered to Raton by train in 1950. (Authors' collection.)

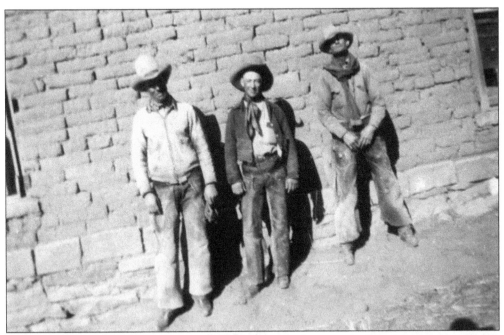

These CS Ranch cowboys took care of the cattle in both summer and winter at the Caliente Camp. Their responsibilities included feeding in the winter, warding off predators, and watching over mother cows during spring calving. After all calves were born, the cowboys would brand them with a CS to show that they were property of the ranch. (Authors' collection.)

Once calves had been branded, earmarked, castrated, and inoculated, they were released to find their mothers who would comfort them after the "rough treatment" they had received at the hands of the cowboys. Cowboy branding crews were so efficient that the entire process usually took less than five minutes per animal and was soon forgotten by the calf. (The Old Mill Museum.)

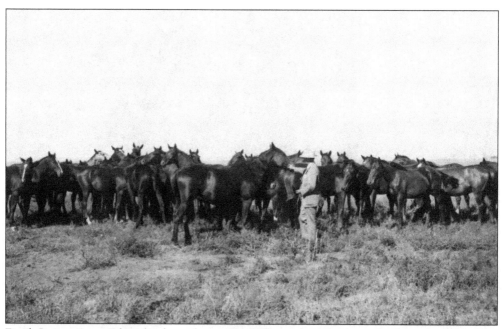

Frank Springer's son Edward is shown here with CS Ranch broodmares and colts in the 1930s. The CS Ranch has been known for more than a century for the quality of its colts. After training, the horses could race, handle cows, or play polo depending on their calling. (Authors' collection.)

William J. Heck (1908–1991), pictured here shoeing a horse in 1943, was the grandson of John Mathias Heck, who had ranched and farmed south of Cimarron since the 1870s. In fact, Mathias Heck's brand, MH, is one of the oldest in New Mexico. Bill Heck ran steers in Moreno Valley in the 1930s and 1940s. Each fall, he and his cowboys drove steers through Cimarron Canyon to the St. Louis, Rocky Mountain & Pacific Railway terminus in Ute Park for shipment to Kansas City. (Library of Congress.)

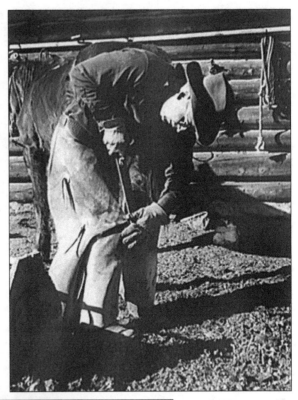

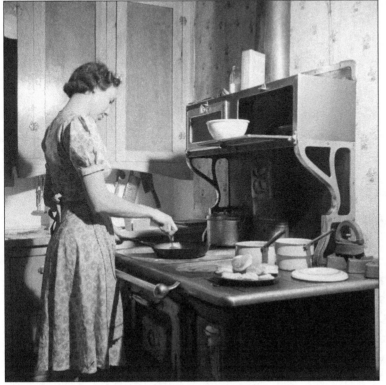

Bill Heck's wife, Geneva (1915–2008), shown here making supper on a wood-burning stove, cooked for the cowboys on her husband's ranch; biscuits were her specialty. She also prepared meals and delivered them to the ranch crew as it moved cattle around the ranch. (Library of Congress.)

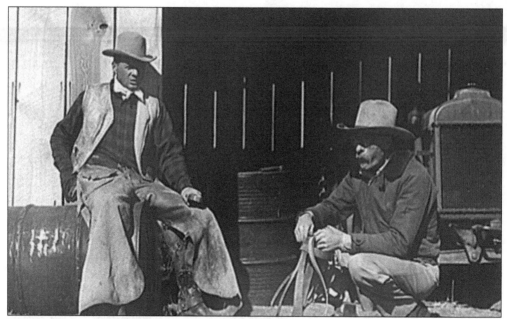

John Mutz (1907–1981), pictured here on the left at his ranch west of Elizabethtown, was grandson of Herman Mutz, who operated the Story Hotel in the mining town during the late 1860s. Like many miners, Mutz bought grazing range in the Moreno Valley from the Maxwell Land Grant Company after the boom mining days had ended. With John Mutz is George Turner of Cimarron whose numerous patents included a cattle chute and a cattle-branding table. (Library of Congress.)

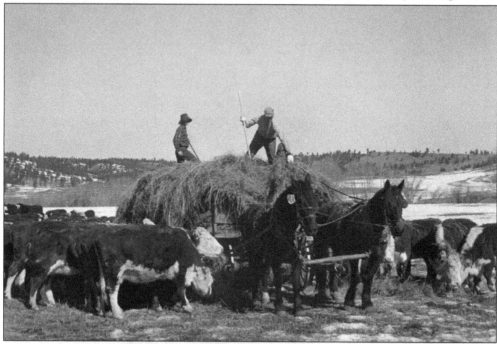

These men are feeding hay to cows on the Mutz Ranch in the early 1940s. Because of the freezing weather conditions in Moreno Valley in the winter, timothy hay was cut each summer to feed to cows when the snow began to fly. (Library of Congress.)

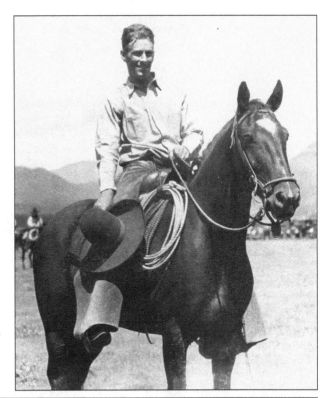

Brownlow Wilson (1900–1985) (right and below) was born in Scotland. He came to Colfax County in 1923 to manage his father's cattle operation in Cimarron, the WS Ranch (after Harold C. Wilson and Montague Stevens). Being an English subject, he was called to serve in the Royal Navy during World War II. After the conflict, he was forced to sell the ranch when his father died. The WS was purchased by W.J. Gourley in 1945 and later added to the Vermejo Park Ranch. (Both, authors' collection.)

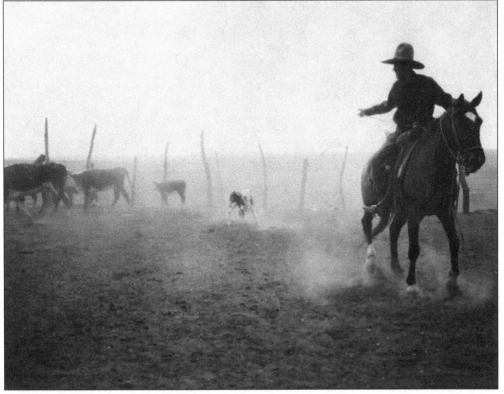

William Bartlett, a grain dealer from Chicago, bought 220,000 acres from the Maxwell Land Grant Company in 1901. The mountainous part was priced at 30¢ per acre, while the grazing pastures were priced at $1 each. In 1907, Bartlett built this 20-room stone house to entertain guests, naming it Casa Major. (Vermejo Park Ranch.)

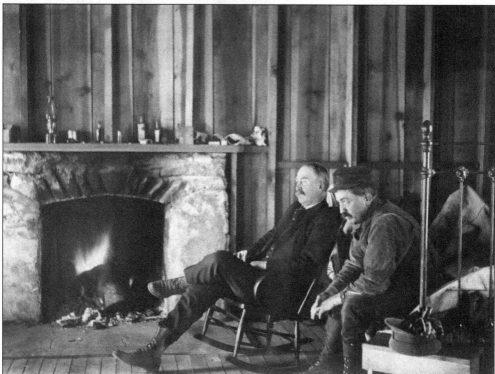

William Bartlett (1850–1918) is pictured at his lodge at Castle Rock Park, which was one of several he built in the Vermejo backcountry near lakes that he had developed. In 1912, Bartlett described himself as being "a cattleman in the mountains of New Mexico with a ranch half the size of the State of Rhode Island and cattle on a thousand hills." (Vermejo Park Ranch.)

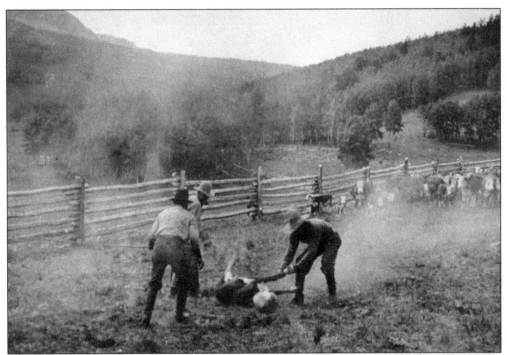

H.W. Adams partnered with William Bartlett to run cattle on the Vermejo. He started his Adams Cattle Company and built barns, corrals, and bunkhouses up the Vermejo River from the site of Casa Major. By 1910, Adams was running more than 6,000 head of cattle, branded with his A6, on Vermejo's pastures. (Vermejo Park Ranch.)

After William J. Gourley (1890–1970) bought the historic WS Ranch near Cimarron in 1945, he added the expansive Vermejo Park Ranch located west of Raton three years later. The combined ranch comprised more than 480,000 acres. He stocked the ranch with several thousand head of cattle and marked them with the WS brand. In addition, he brought Rocky Mountain elk from Yellowstone Park to the ranch, where they had not ranged for 50 years. (Authors' collection.)

This Vermejo cowboy, pictured in 1915, has rescued a dogie calf that had lost its mother. The calf was probably carried in the saddle back to headquarters where it would have been bottle-fed until it was able to fend for itself. Wolves were a constant threat to the cattle at the time. (Vermejo Park Ranch.)

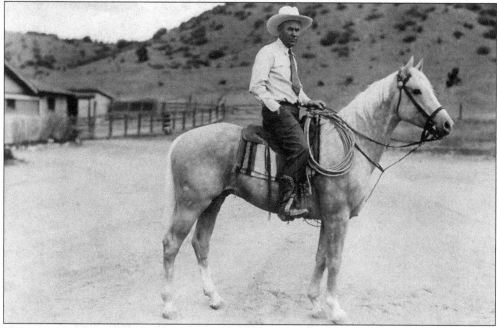

Philmont Ranch manager Roy Lewis is pictured here on Plaudit, the ranch's most well-known stallion in the 1930s. The palomino horse was half-Thoroughbred and was chosen as one of the foundation sires of the American Quarter Horse Association in 1940. Plaudit excelled at running, playing polo, and working cattle. (Authors' collection.)

Jesus Abreu was known for the high quality of the horses he raised on his Rayado Ranch. Here, his son, Narciso, brands a colt. The ranch's brand, "the Pear," is one of the earliest registered in New Mexico. (Philmont Museum.)

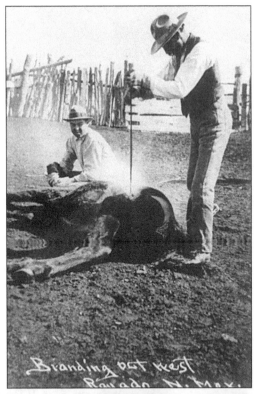

Alice Moore, pictured here throwing a perfect heel loop at a CS branding, was raised on her family's ranch north of Eagle Tail Mountain. Her father was noted for his quarter horse–breeding program marked by stallions and broodmares that produced colts displaying excellent conformation, calm dispositions, and athletic ability. Alice has continued her father's legacy to the present day. (Authors' collection.)

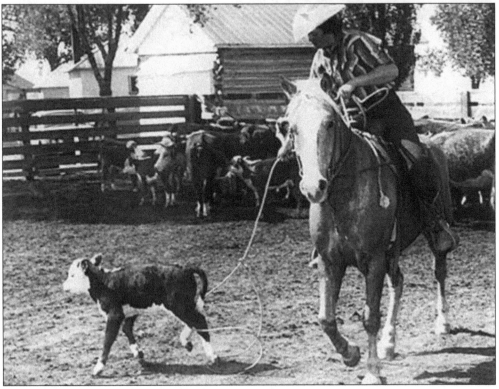

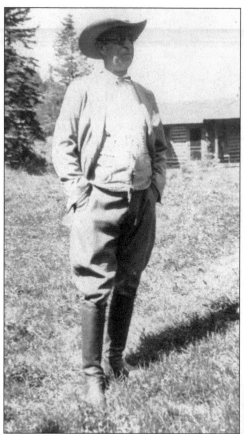

Waite Phillips (1883–1964) was born in Iowa in 1883. As a young man, he went to Indian Territory to work in the oil fields with his brothers. In 1925, Phillips sold his own oil business, the Waite Phillips Company, for $25 million. In 1922, he began buying old Maxwell Land Grant ranchland around Cimarron and established Philmont Ranch. In 1941, he and his wife, Genevieve, gave half of the ranch to the Boy Scouts of America, which established Philmont Scout Ranch as a wilderness camping area for its members. (Philmont Museum.)

Waite Phillips began buying ranches in the Cimarron area in 1922. Ten years later, he had put more than 300,000 acres under one fence in a ranch that he named Philmont, derived from his name and the Spanish word for mountain, *monte*. Philmont Ranch was known throughout the West for the quality of the horses, cattle, and sheep that it produced. (Philmont Museum.)

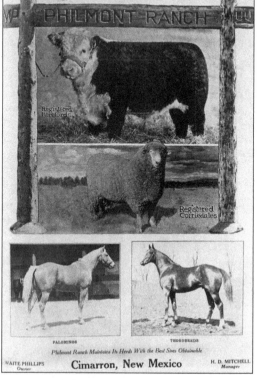

Waite Phillips is pictured here in 1933 with his son Elliott, known as "Chope," on the right and Chope's roommate at Culver Military Academy, Donn Davies. The boys spent the summer that year on horseback on the ranch. After Phillips gave half of the ranch to the Boy Scouts of America in 1941 and sold the other half, Chope bought a ranch at Valmora, New Mexico. (Philmont Museum.)

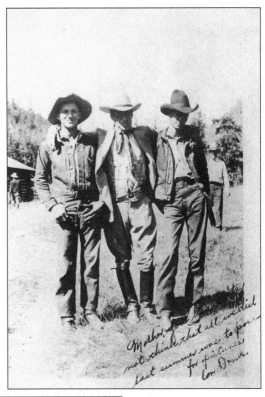

Donn Davies (1916–2005) graduated from the University of Arizona, where he won the National Collegiate Saddle Bronc Riding Championship. In 1937, he spent six weeks working for the Armour and Swift companies in Argentina, driving cattle from high in the Andes down to the Atlantic coast. He subsequently ranched in Wyoming and eventually retired to Cimarron, where he enjoyed braiding rawhide ropes, hackamores, and reins. (Philmont Museum.)

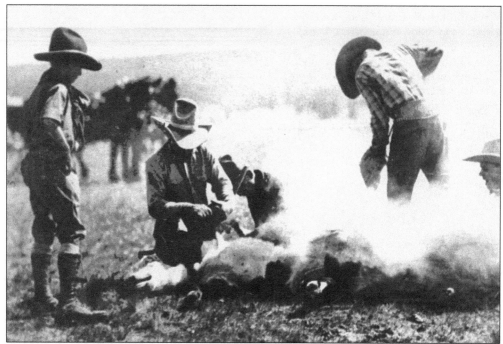

Each spring after the Philmont Ranch Hereford cows had given birth to their calves, they were driven from the lower winter pastures up to high-country parks in the southwest part of the ranch. There, the calves were branded with Waite Phillips's Double U Bar in La Grulla Park. Afterward, the cows and their calves were scattered throughout the meadows to graze on the rich summer grass. (Philmont Scout Ranch.)

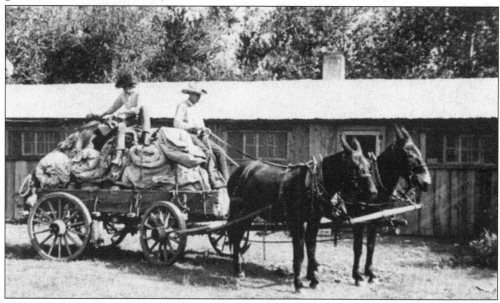

Philmont cowboys' roundup beds were hauled in this wagon pictured in front of the Zastro Cow Camp in the 1930s. Inside the long doubled-up canvas tarp, each man would have blankets and a sheet along with extra clothes and assorted personal items. The beds were rolled for carrying and bound with ropes or latigos. (Philmont Museum.)

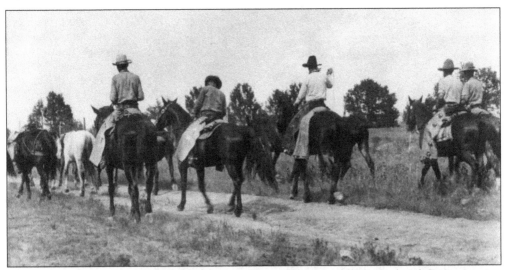

These Philmont cowboys are trailing the ranch's remuda, or saddle horse band. During spring and fall, the cowboys would drive their saddle horses with them as they moved into new pastures, branding calves in the spring and gathering them for shipment in the fall. (Philmont Museum.)

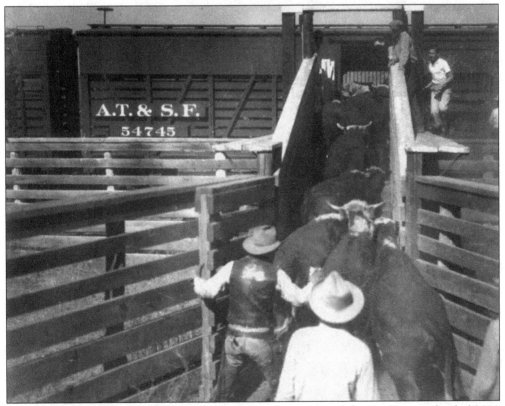

Each fall in the 1920s and 1930s, Philmont Ranch cowboys gathered the ranch's entire herd of 6,000 head of Hereford cattle. After weaning the calves from their mothers, the cowboys drove them to Cimarron, where they were loaded onto St. Louis, Rocky Mountain & Pacific railcars and later transported by Santa Fe Railway trains for eventual sale in Kansas City. (Philmont Museum.)

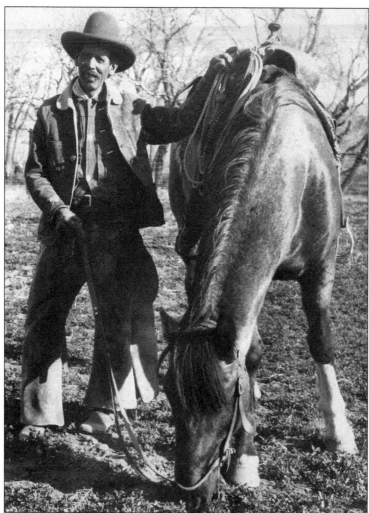

Melaquias Espinosa worked on Waite Phillips' Philmont Ranch in the 1920s and 1930s. He was a universal favorite among the ranch's cowboys and the residents of Cimarron. He was also recognized as a top hand, especially skilled in handling cattle in the mountain pastures of the ranch. (Philmont Museum.)

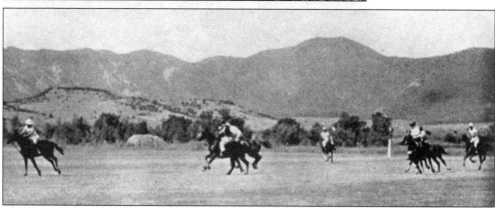

Both the Philmont and CS Ranches raised and trained polo ponies during the 1930s. Each had polo teams that played in tournaments as far away as Albuquerque and Colorado Springs. Each year, the two ranches put on a polo pony show at the polo field in Cimarron where they were able to showcase the talents of their horses. (Authors' collection.)

Four

RAILROADING

The Atchison, Topeka & Santa Fe Railway (Santa Fe) laid tracks across Raton Pass into Colfax County in November 1878, and its first locomotive crossed over the pass on December 7. The Santa Fe was the first railroad line to reach New Mexico Territory, and its arrival brought dramatic political, economic, and cultural changes to territorial residents as it transported them into the modern era.

Initially, the line stopped at a spot called Otero, where the railroad planned to establish a division point. Later officials moved the location five miles north to Willow Springs at the foot of Raton Pass because it possessed a better water supply. There, they acquired 320 acres from the Maxwell Land Grant Company for a townsite that they named Raton. Within the next year, the Santa Fe built offices, machine shops, and a roundhouse on the site, and the town boasted more than 400 residents with a full complement of hotels, saloons, and mercantiles.

The Santa Fe continued south into the county, making a stop at Maxwell City and then Springer on the Cimarron River, which was named for land grant company attorney Frank Springer. Springer soon became the primary shipping point for cattle and sheep in the northeastern quadrant of the territory, and its importance as a commercial hub was made known when the seat of Colfax County was moved there in 1881.

Cimarron had held prominence in the county since it served as the headquarters for the Maxwell Land Grant Company when the land was purchased in 1870. It was also named county seat in 1872, when the legislature moved it from Elizabethtown. But Cimarron's fortunes faded in economic and political importance to Springer and Raton toward the turn of the century because it did not have the benefit of railroad transportation.

Prospects for the town brightened, however, when the St. Louis, Rocky Mountain & Pacific Railway, also known as the Swastika Line (named after a traditional Native American symbol), built tracks into the town in 1906. The branch line had heretofore provided freight service to coal camps, but by expanding into Cimarron, it aggressively sought to transport not only gold ore from Baldy mines, but livestock and timber products as well.

In 1908, the Continental Tie & Lumber Company opened for business in Cimarron and began harvesting timber out of the Ponil Canyons northeast of town. Its subsidiary, the Cimarron & Northwestern Railway Company, hauled both raw logs and processed ties and mine props from the company sites of Ponil Park, Ring, Bonita, and Pueblano into Cimarron for transfer to St. Louis, Rocky Mountain & Pacific cars.

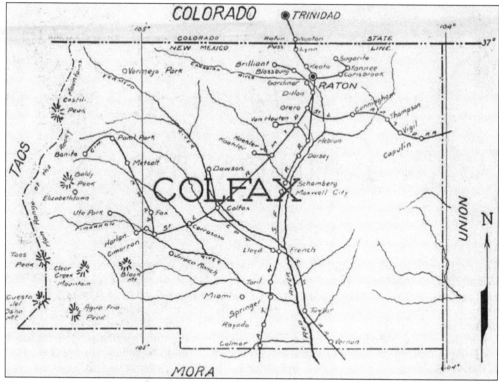

This map of Colfax County is included in the Official Souvenir Book of New Mexico published for the Panama-California Exposition held in San Diego in 1915–1916. The exposition promoted the arts and commerce of each southwestern state and was organized to celebrate the opening of the Panama Canal. Shown here are the routes of the various county railroads. (Authors' collection.)

This photograph shows the town of Raton as seen from Goat Hill, where the old road winds down off Raton Pass from Trinidad. The present highway, now Interstate 25, was built in 1915. (Arthur Johnson Memorial Library.)

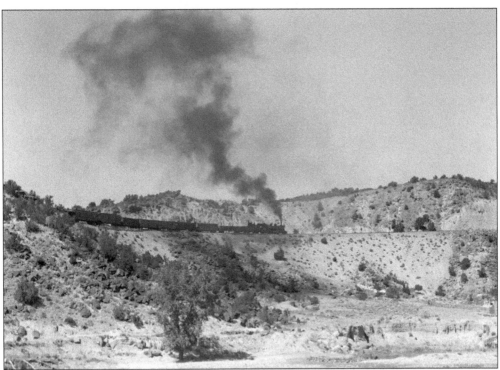

The Santa Fe Railway retraces much of the route of the toll road that Richens "Uncle Dick" Wootton built over Raton Pass in 1867, connecting La Junta and Trinidad, Colorado, in the Arkansas River valley with Raton, New Mexico, in the Canadian River valley. Santa Fe Trail travelers as well as railroad locomotives required reliable sources of water. (New Mexico Department of Tourism.)

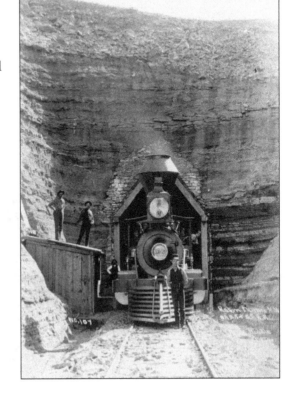

1881 Raton Tunnel Santa Fe Locomotive No. 193

The first Santa Fe tracks that crossed over Raton Pass followed a series of switchbacks until a 2,000-foot tunnel was cut through at the highest point in 1879. A second 2,800-foot tunnel was later cut that significantly reduced the grade from the original 2 percent to less than 0.2 percent. (Arthur Johnson Memorial Library.)

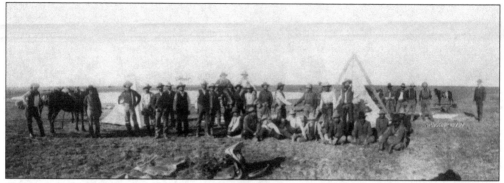

Cowboys held their herds on open range east of Springer in advance of shipping on the Santa Fe line back to Kansas City markets. The introduction of barbed wire in the 1870s kept cattle from overgrazing land but made it more difficult for herds to be driven to market. (Santa Fe Trail Museum.)

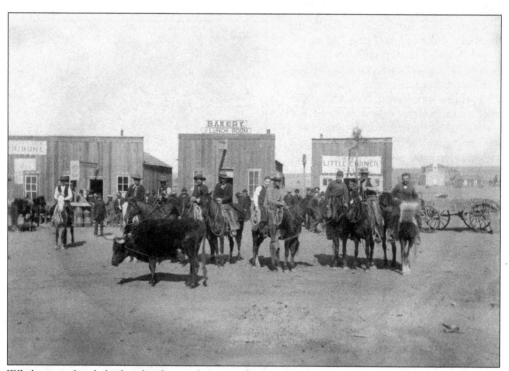

While some herds had to be driven from ranches as far as 300 miles away, the convenience of rail stations at Raton, Maxwell, Springer, Cimarron, and Ute Park was certainly a boon to the local cattle industry. These cowboys in early-day Springer have roped a steer and brought him to town for a barbecue. (Santa Fe Trail Museum.)

Raton artist Manville Chapman painted this mural of Willow Springs, an important stop on the Santa Fe Trail at the southern foot of Raton Pass. With the arrival of the railroad in 1879, Willows Springs was renamed Raton, Spanish for "mouse," a year later. Painted in the mid-1930s, the mural is on display in the lobby of the Shuler Theater in Raton. (Authors' collection.)

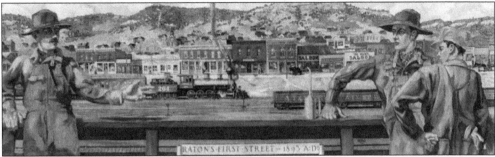

This Chapman mural from the Shuler Theater depicts Raton's First Street, originally named Railroad Avenue, with Goat Hill to the west in the background. The street runs beside the Santa Fe depot and tracks. (Authors' collection.)

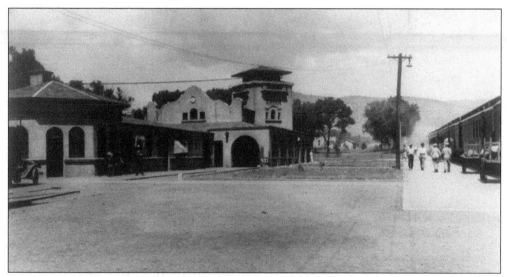

Raton's second depot was built in 1904. The Wells Fargo Express Company built a freight office next door in 1910. (Arthur Johnson Memorial Library.)

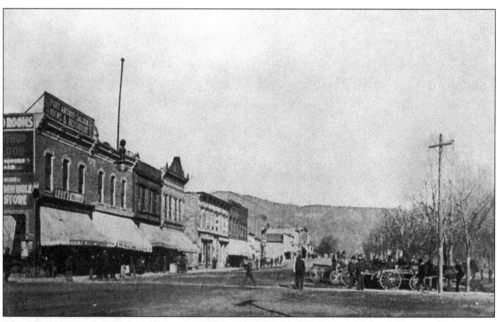

The town of Raton was founded in 1880 after the Santa Fe Railway laid tracks over Raton Pass. The first residents lived in tents. This photograph shows Raton's Main Street, originally named Santa Fe Avenue, as it looked at the turn of the 20th century. (University of New Mexico.)

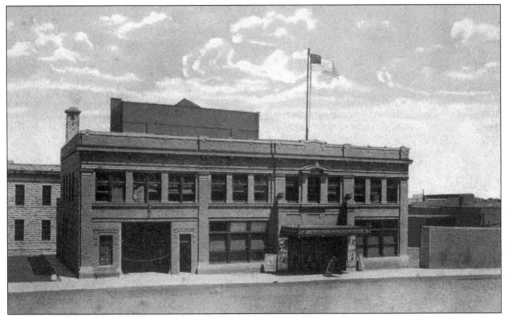

Raton's city auditorium was built in 1914. It was the inspiration of the mayor, Dr. John Jackson Shuler, and was designed by William Rapp of Trinidad. When Dr. Shuler died in 1919, the city council passed a resolution naming it after him. It continues to host an active schedule of plays and concerts. (Randall M. MacDonald.)

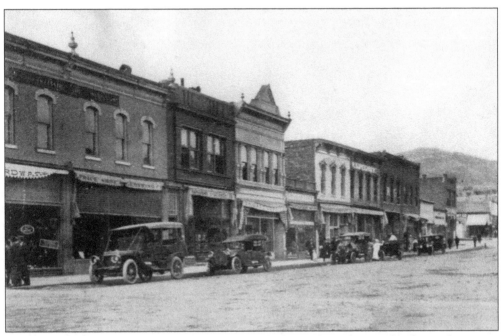

By 1912, when this photograph was taken, Raton had transformed into a bustling, vibrant city propelled by ranching, railroading, and coal mining (compare the photograph at the bottom of the opposite page). (Arthur Johnson Memorial Library.)

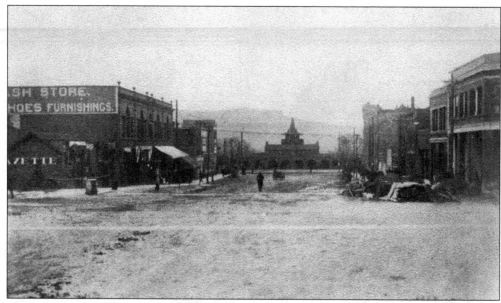

This photograph shows the view along Cook Avenue from Main Street, now Second Street, east toward the Santa Fe depot. Wide streets and imposing storefronts were typical features of up-and-coming western towns that wanted to impress visitors as they stepped off the train. (Arthur Johnson Memorial Library.)

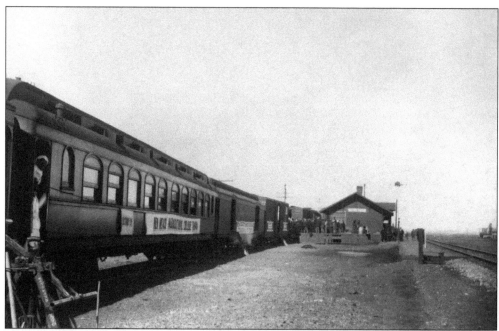

Maxwell City (later renamed Maxwell) was established in 1879 as a railroad stop for the Atchison, Topeka & Santa Fe Railway. The banner on the train stopped at the Maxwell station reads, "New Mexico Agricultural College Train." (The Old Mill Museum.)

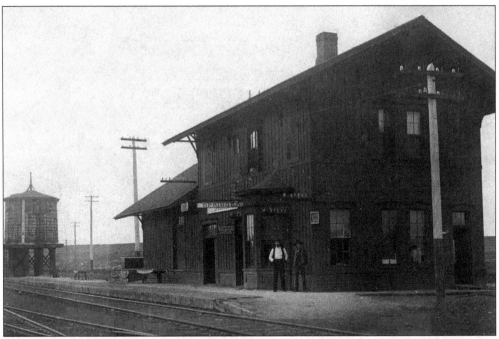

The original Santa Fe depot in Springer was built soon after tracks were laid in 1879 and the town established on 320 acres of land owned by Frank Springer, after whom the town was named. Stockyards were soon constructed west of town, and Springer became the primary livestock shipping point for northeastern New Mexico Territory. The first town merchants were C.A. Clouthier and H.W. Porter (see page 81). (Santa Fe Trail Museum.)

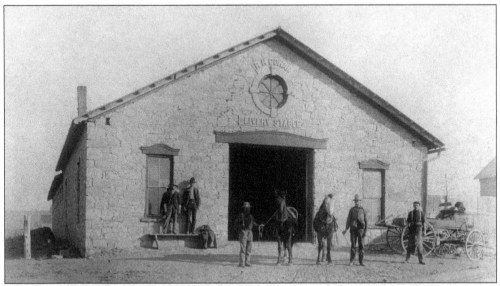

Cowan's livery stable was built of sandstone blocks. It provided important services such a boarding horses and renting saddle horses and buggies and teams. In addition, the liveryman sold hay and grain and bought and sold horses and mules. The building still stands today. (Santa Fe Trail Museum.)

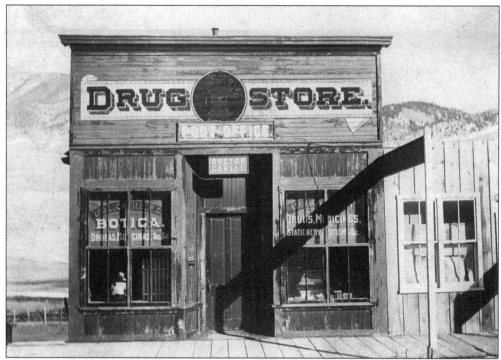

Dr. L.L. Cahill was a popular physician and druggist in Springer during the first decades of the 20th century. He died in 1919 from influenza, having contracted it as a result of administering to more than 150 afflicted patients during the epidemic. (Santa Fe Trail Museum.)

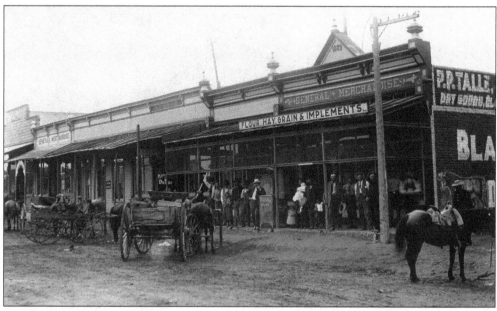

P.P. Talle's store, pictured in 1909, was one of several mercantiles found in Springer after the turn of the 20th century. They all did a brisk business with patrons coming from all parts of the county and beyond. (Santa Fe Trail Museum.)

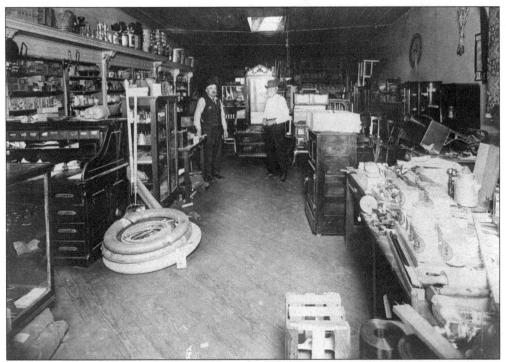

Henry Porter moved his store from Cimarron to Springer when the railroad came to town and took on D.A. Clouthier as partner. An observer in 1882 noted that their store did $60,000 worth of business in a month: "A ranch man may not come often, but when he comes, he loads up $300 to $1,200 worth of goods." (Santa Fe Trail Museum.)

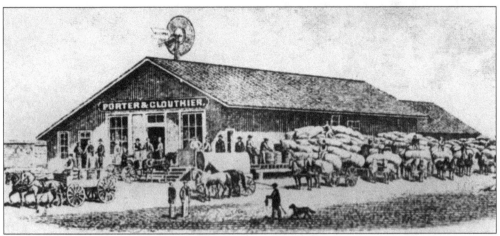

This is a representation of Porter & Clouthier's Commission House. It was described as being "about 150 feet long and full of everything used by man or beast, from a cambric needle to a four-horse wagon." (Santa Fe Trail Museum.)

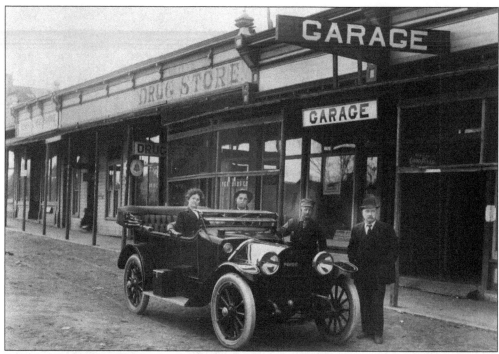

Dosethe A. Clouthier (1853–1939) was born in French Canada and came to Taos as a young man to clerk for Charles Beaubien. After he ended his partnership with Henry Porter, Clouthier entered the automobile business in Springer. In this 1911 photograph, he is pictured on the right at his garage, which was located in the P.P. Talle Building. Sitting in the Paige-Detroit automobile are a Miss LaBrier and Blanche Clouthier, D.A.'s brother; garage mechanic John Lauterbach stands next to the vehicle. (Santa Fe Trail Museum.)

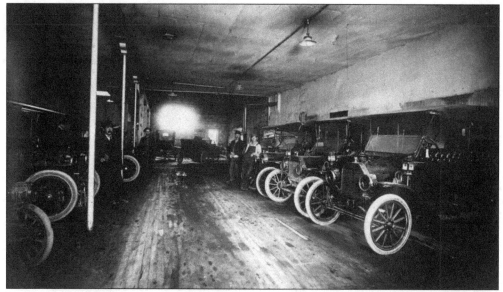

The inside of Clouthier's automobile business showcased the latest models at a time when frontier New Mexico was just moving from its horse-drawn days to those of horsepower engines. (Santa Fe Trail Museum.)

After opening stores in Las Vegas, Watrous, and Ocate, New Mexico, Sol Florsheim bought out Porter & Clouthier's Springer business in 1896 and soon became one of the largest wool dealers in the county at a time when sheep were a major industry. Black shawls were a popular store item among local Spanish women. Florsheim also acquired extensive ranchland east of Springer where he established the Jaritas Ranch and raised sheep. (Santa Fe Trail Museum.)

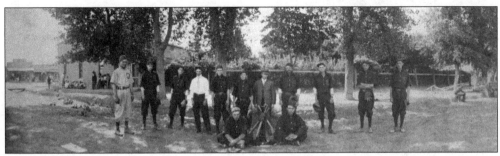

Springer's baseball team played teams from Cimarron, Raton, and the coal mining camps of Colfax County after the turn of the 20th century. Games were usually played on Saturday and Sunday afternoons and were well attended. (Santa Fe Trail Museum.)

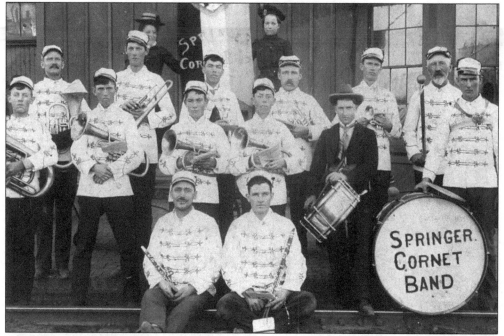

The Springer Cornet Band was established two years before this 1905 photograph. The band provided popular music that entertained town residents at parades, dances, and concerts. (Santa Fe Trail Museum.)

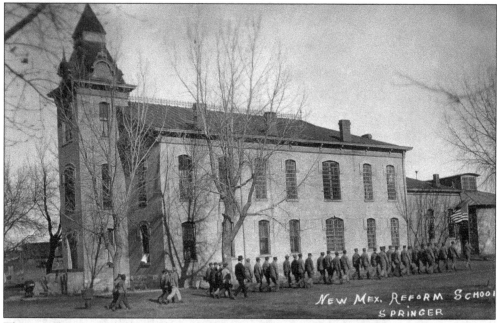

This courthouse was built in 1881 when the seat of Colfax County was moved from Cimarron to Springer. Along with a second-floor courtroom, the courthouse boasted a gallows constructed in the top floor of the tower. The building also served as the judicial headquarters of the county until the seat was moved to Raton in 1897. As shown here, the courthouse was also the first home of the New Mexico Reform School from 1910 to 1917. (Santa Fe Trail Museum.)

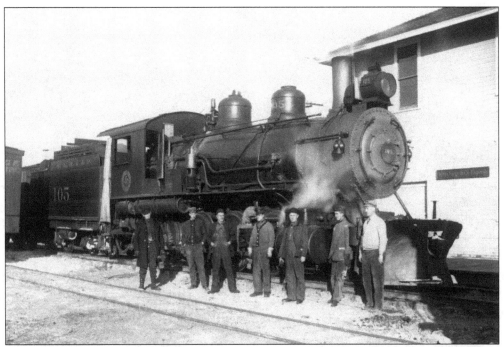

Here, the St. Louis, Rocky Mountain & Pacific Railway's Baldwin No. 105 locomotive is pictured with the engineer and crew in front of the Cimarron depot. In 1914, the Santa Fe Railroad purchased the company and its rail lines, and the roundhouse was dismantled and moved to Raton. (The Old Mill Museum.)

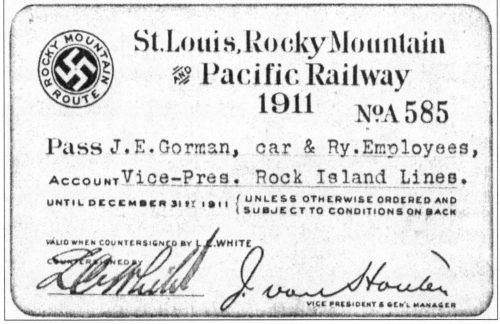

This 1911 St. Louis, Rocky Mountain & Pacific pass was authorized by the company's vice president and general manager, Jan Van Houten, who also supplied fuel to the company from his coal mines. (Authors' collection.)

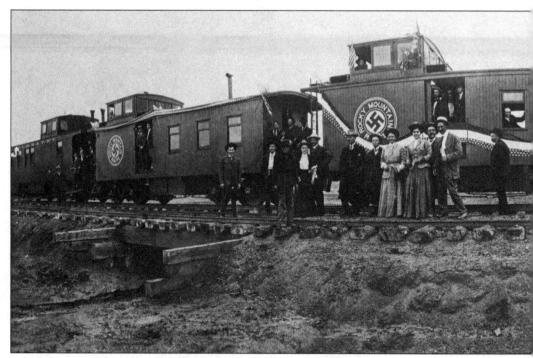

The first train on the St. Louis, Rocky Mountain & Pacific Railway, or "Swastika Line" because of its distinctive logo, arrived in Cimarron from Raton on December 10, 1906. To celebrate the occasion, two townsmen set up blacksmith anvils packed with gunpowder. When the locomotive

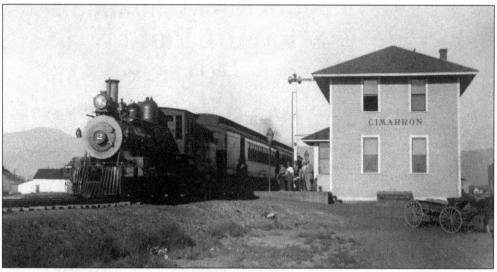

The St. Louis, Rocky Mountain & Pacific Railway Company built a train depot next to the tracks north of the Cimarron River in 1906. A year later, officials constructed a fully equipped roundhouse nearby to service locomotives. Although the roundhouse is gone, the turntable pit can still be seen. Passengers are seen here boarding the train for Raton. (The Old Mill Museum.)

came into view, they exploded the powder, which created a deafening ringing noise that pleased all onlookers. (The Old Mill Museum.)

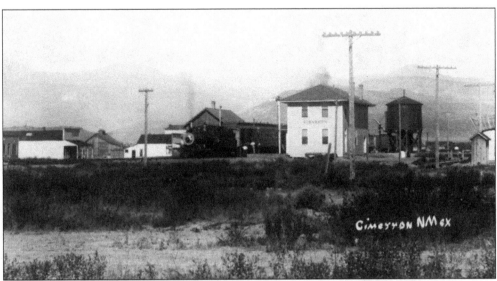

The ticketing office and waiting room of the station are on the ground floor, railroad offices are on the second floor, and the view from a top left window looks out from a bedroom. (The Old Mill Museum.)

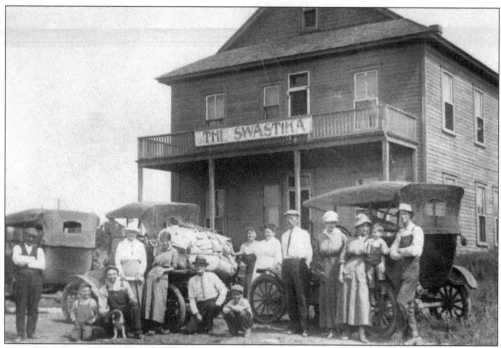

The Swastika Hotel was built by the railroad about 1907. It was one of several hotels constructed after the railroad came to Cimarron, including the Oxford, which opened with an elaborate dinner in April 1907, and the Grand. (Rosso family.)

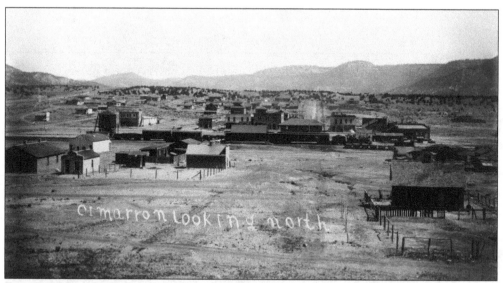

The Cimarron & Northwestern Railway Company, a subsidiary of the Continental Tie & Lumber Company, started operations in 1907. With the arrival of two railroads, the population of Cimarron increased dramatically. A group of entrepreneurs incorporated the Cimarron Townsite Company and acquired 225 acres beside the railroad tracks. Soon, there was a building boom in what was referred to as "New Town." In this view looking north along Washington Avenue, the station can be seen in the center. (The Old Mill Museum.)

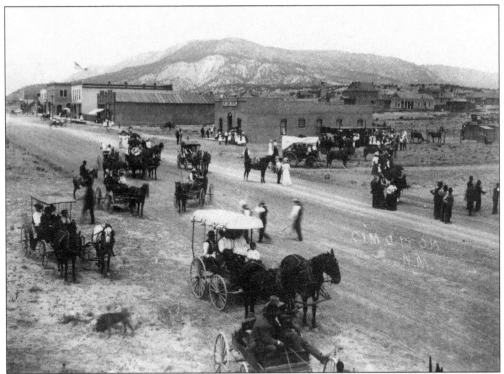

Cimarron's New Town main street (Ninth Street) was photographed on the Fourth of July, 1911, in celebration of New Mexicans having approved their first state constitution. On January 6 the following year, President Taft signed a document welcoming New Mexico as the 47th state. The Antlers Hotel is in the center of the photograph with other businesses to the left in the background. (The Old Mill Museum.)

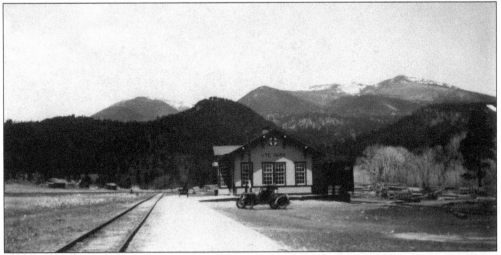

The overly ambitious plan of the St. Louis, Rocky Mountain & Pacific Railway was to lay tracks from Cimarron through the canyon to the west, into the Moreno Valley, and on to Taos. From there, it was advertised to go all the way to California and the Pacific. Unfortunately, economic conditions prevented expansion beyond the 12 miles to Ute Park, where this station was built in 1908. (Arthur Johnson Memorial Library.)

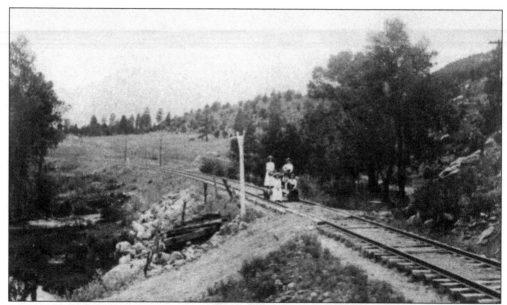

These ladies are enjoying a pleasant afternoon traveling by handcar east of Ute Park. While not a particularly lucrative extension of the line, the St. Louis, Rocky Mountain & Pacific Railway offered passenger service from Cimarron to Ute Park. In addition to the railway station, a large pavilion and lunch counter were built in the scenic Ute Creek valley for passengers who would come on a weekend to enjoy a baseball game, picnic, or dance. (Arthur Johnson Memorial Library.)

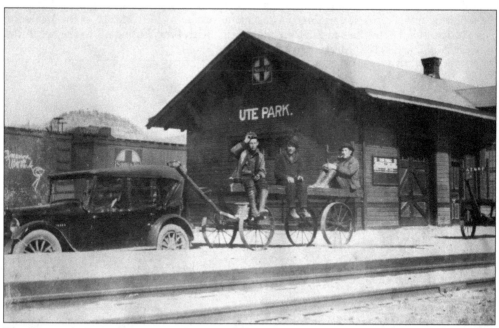

The three-mile line extension from Cimarron to Ute Park through Cimarron Canyon took only about a month to build, finishing in January 1907. Once in Ute Park, passengers and goods could continue on to Moreno Valley and Taos via the Hankins Stage Line; H.H. Hankins was the local station agent. (Hickman family.)

Five

MINING

One fall day in 1866, three soldiers from Fort Union, New Mexico, camped beside Willow Creek in the western part the Maxwell Land Grant. While prospecting the placer gravel of the creek for gold, one of the men discovered flakes in his pan and called for his camp mates to join him. Pleased with the amount of "color" they saw, the men worked furiously for the next few days. When snow began to fall, they returned to the fort, each agreeing not to divulge their discovery.

When they came back to the mountains in the spring, they were shocked to find other soldiers prospecting not only around their claim, but all along the other creeks and gulches that ran down from Baldy Mountain into Moreno Valley. By midsummer, more than 130 claims were recorded and more prospectors were on their way. So many men swarmed the goldfields that several enterprising miners organized a town named Elizabethtown on the west side of the valley opposite Baldy Mountain, with land available for both businesses and residences.

Mining activity shut down with the advent of freezing weather, and the miners repaired to E-town to avail themselves of the hotels, restaurants, and saloons. But with the coming of spring, they were back prospecting the placer deposits along the valley. Their efforts were hindered by the lack of water needed to wash the gravel and separate the heavier gold flakes. Several projects were attempted to bring runoff water from the upper valley, but few were successful. By the end of the 1870 season, the richest placers had been worked and the majority of miners left in search of better opportunities.

Even more important to the development of Colfax County than gold was coal. The first coal mine opened in 1880 at Otero south of Raton, which was followed two years later by the Gardiner mine in Dillon Canyon west of town. That mine and nearby Blossburg were concerns of the Raton Coal and Coke Company, a joint venture between the Santa Fe Railway and the Maxwell Land Grant company.

In 1905, Raton Coal and Coke operations were acquired by the St. Louis, Rocky Mountain & Pacific Company, which extended the rail line to a new camp called Brilliant. Eventually, the company took over Van Houton, a working mine southwest of Raton, and developed new mines at Koehler (1907) and Sugarite (1912). Each camp was provided with freight service through its subsidiary, the St. Louis, Rocky Mountain & Pacific Railway. The bituminous coal from these mines was used to fuel locomotives and was also manufactured into coke for smelting copper ore. By 1908, there was almost 1,000 coke ovens in Colfax County, principally located at the Gardiner, Blossburg, Koehler, and Dawson camps.

The Dawson Fuel Company opened the first coal mine on John Dawson's ranch on Vermejo River in 1901. The mine closed in 1950 due to decreased demand. The majority of company houses where miners lived were subsequently moved to the nearby towns of Cimarron, Springer, and Raton, and the town that once boasted a population of more than 9,000 people was no more.

The
MAXWELL LAND GRANT,

Situated in New Mexico and Colorado,
On the Atchison, Topeka & Santa Fe
and Union Pacific, Denver & Gulf,

1,500,000 ACRES OF LAND FOR SALE.

FARMING LANDS UNDER IRRIGATION SYSTEMS.

In tracts of 20 acres and upward, with perpetual water rights—cheap and on easy terms of ten annual payments with 7 per cent. interest—Alfalfa, Grain and Fruit of all kinds grown to perfection.

CHOICE PRAIRIE OR MOUNTAIN GRAZING LANDS.

Well watered with good shelter, interspersed with fine ranches suitable for raising grain and fruits—in size of tracts to suit purchaser.

LARGE PASTURES FOR LEASE, for long term of years, fenced or unfenced; shipping facilities over two railroads.

GOLD MINES.

On this Grant near its western boundary are situated the famous Gold Mining Districts of Elizabethtown and Baldy, where mines have been successfully operated for 25 years, and new rich discoveries were made in 1895 in the vicinity of the new Camps of Hematite and Harry Bluff as rich as any camp in Colorado, but with lots of as yet unlocated ground open to prospectors on terms similar to, and as favorable as, the United States Government Laws and Regulations.

The stage for these camps leave Springer station on the A. T. & S. F. R. R. every morning, except Sunday.

TITLE perfect, founded on United State Patent and confirmed by decisions of the United States Supreme Court.

For further particulars and pamphlets apply to

THE MAXWELL LAND GRANT CO.,
Raton, New Mexico.

Advertisements such as this in eastern newspapers promoted the sale of land on the Maxwell Land Grant by the land grant owners. This ad would have been placed after the US Supreme Court's decision upholding the legitimacy of the grant in 1887. Note the exaggeration of gold mining compared to farming. (Authors' collection.)

With the influx of miners into Moreno Valley in 1867, a townsite west of Baldy Mountain was surveyed. It was named Elizabethtown after the daughter of Capt. William H. Moore, one of the town's founders. "E-town," as it was known, boasted five mercantile establishments that sold supplies to miners. By 1868, the town of 7,000 was the largest in the state. Four years later, as claims dried up, only 100 residents remained. (Authors' collection.)

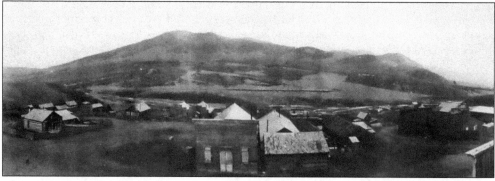

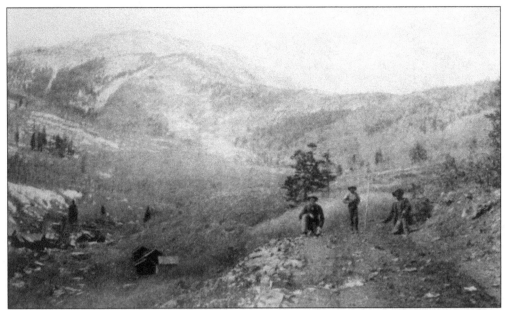

Placer gold was found in many of the creeks of the Moreno Valley, including Ute Creek to the east, seen here in the 1860s. Prospectors such as these used pans to wash and separate the heavier gold flakes and occasional nugget from the gravel of streams. (Philmont Scout Ranch.)

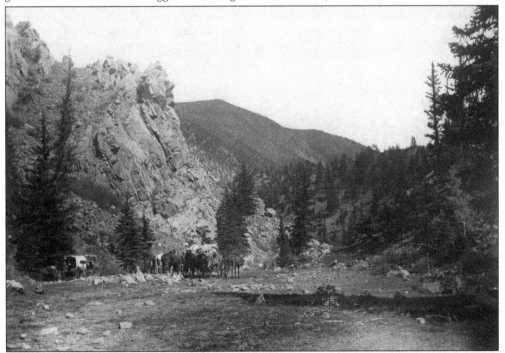

Once the flood of miners entered the Moreno Valley, $4,000 was spent in 1868 developing a road through narrow Cimarron Canyon to the goldfields. After the work was completed, stage service was implemented from Maxwell's Ranch to Elizabethtown. This photograph with a view looking east shows the entrance to Cimarron Canyon at the location where Eagle Nest Dam would be built in 1918 (see page 50). (Randall M. MacDonald.)

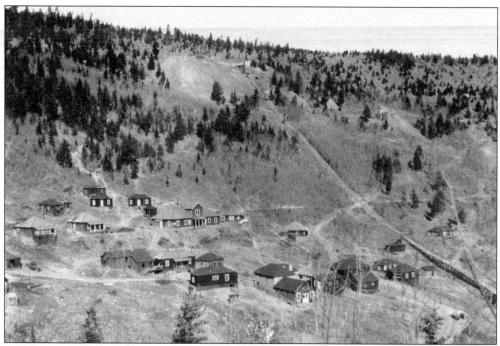

Here is the gold mining town of Baldy in the 1930s, during its last decade of existence. The Baldy Hotel stands in the center, surrounded by miners' houses. At the top is the mine entrance with the tram that transported ore down to the stamp mill. (Philmont Museum.)

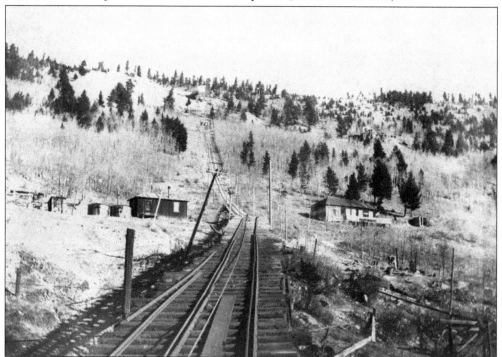

This is a view of the tramway from the stamp mill up toward the mine tunnel entrance. (Philmont Museum.)

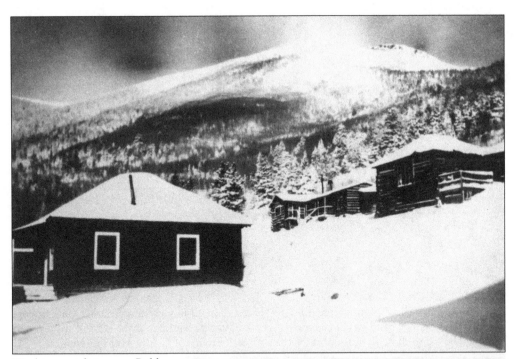

Working conditions on Baldy Mountain were so harsh and cold in the winter that the mine often closed. Many miners left Baldy Town for other work in nearby communities and returned once the town had thawed in the spring. Nestled beneath the mountain summit, the town, whose population peaked at 2,000 in 1880, was situated at an elevation of over 10,000 feet above sea level. (Philmont Museum.)

In 1900, W.P. McIntyre began to tunnel through Baldy Mountain, hoping to strike the mother lode that he was sure was there. After 36 years of grueling work, six years after McIntyre died, none was ever found. Today, only ruins remain amid stately stands of aspen to serve as reminders of what men would endure in their pursuit of riches. (Philmont Museum.)

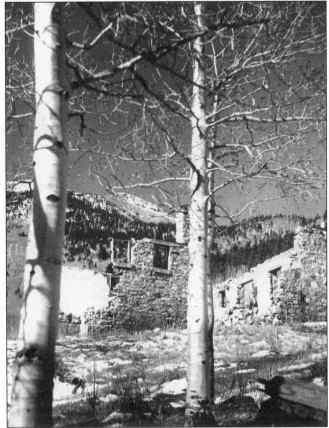

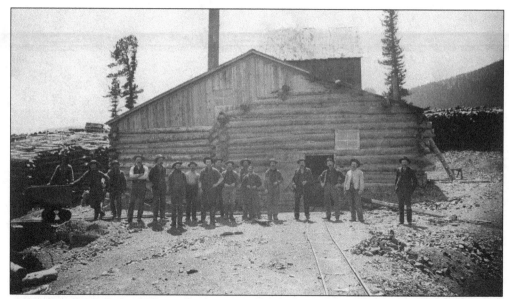

Aztec miners like these photographed in 1894 often enjoyed boxing matches that were held at Baldy Town. In 1898, residents of the town gathered after the sinking of the battleship *Maine* in Havana Harbor to show their support for the war with Spain. (The Old Mill Museum.)

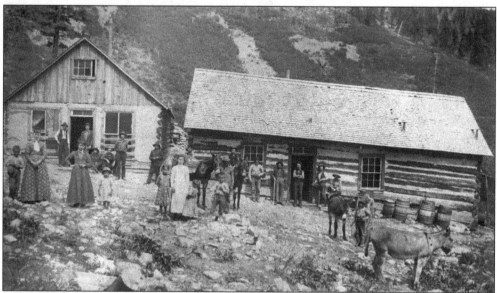

While a miner's life was hard work, families came along in support: wives cooked and cleaned house and children went to school. Most miners either worked for a wage at the mine or the stamp mill or prospected claims of their own. (The Old Mill Museum.)

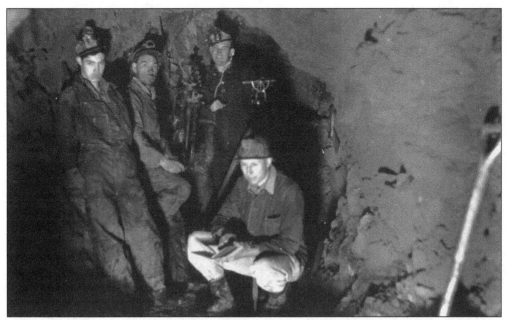

Gold mining was a dark, dirty, and dangerous business, but miners liked to have their photographs taken to show their families what their working environment was like. (Philmont Museum.)

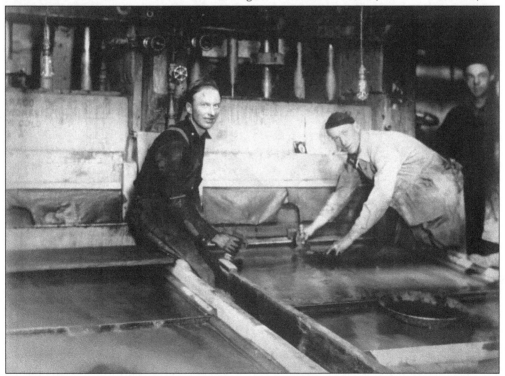

In this photograph, men clean the Aztec Mine stamp mill after it has crushed ore from the mine and gold has been separated from it. Reportedly, ore from the Aztec was valued at $40 a ton during the 1890s. It has been estimated that by 1926 the total production of gold from the mountain had reached $3,500,000. (Philmont Museum.)

In 1869, Henry Buruel from France opened the French Henry Mine on the north side of Aztec Ridge beside the banks of the South Ponil River. Although he obtained a deed to the mine from Lucien Maxwell, he discovered that Maxwell would not mill his rock at the Aztec Mine on the south side of the ridge. Because the cost of shipping ore at the time was prohibitive, the Frenchman closed down his mine. C.H. Anderson worked the mine again in the 1930s until assays brought less that $1 per ton. (The Old Mill Museum.)

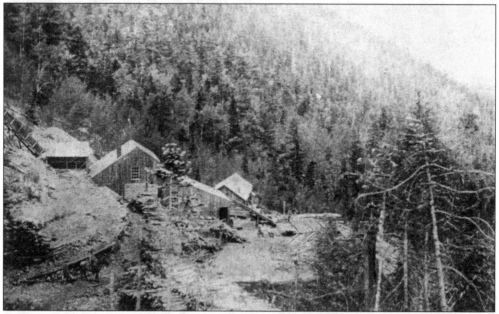

The Black Horse Mine was owned by the Four Creeks Milling and Mining Company. Located south of the Aztec Mine on a tributary of Ute Creek, the mine was active in the 1880s and 1890s. Typical of lode or quartz mines of the time, it was operated by Phillip H. VanZuylen, who employed modern concentrator tables that separated a larger percentage of gold from the ore. (Philmont Museum.)

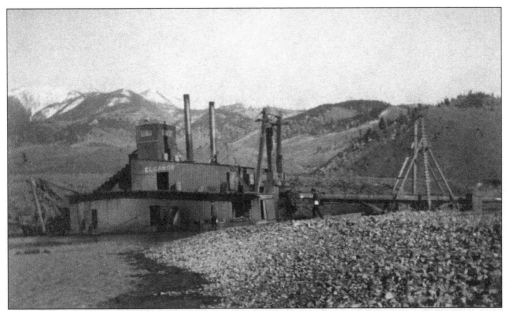

H.J. Reiling of Chicago organized the Oro Dredging Company in 1901. His group constructed a gold-dredging machine in Moreno Valley that he named *Eleanor* (dredges, like vessels at sea, are ladies). It was essentially a land-locked barge and was designed to scoop and wash immense quantities of gold-bearing gravel. The machine was producing $750 to $1,000 worth of gold a day by 1903. (Randall M. MacDonald.)

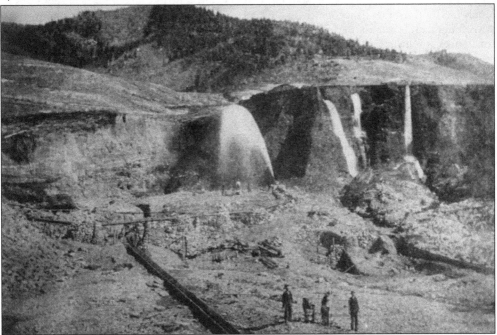

In the 1890s, miners used powerful hoses in Moreno Valley and along Ute Creek to wash away gravel from hillsides, sometimes going down as far as 30 feet to bedrock, a process called hydraulic mining. The gravel was then shoveled into a series of sluice boxes that separated the gold. (Philmont Museum.)

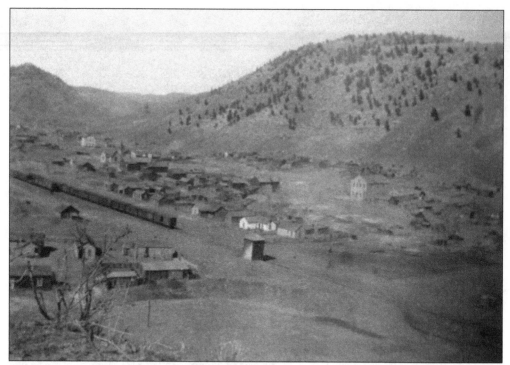

The Santa Fe Railway and its subsidiary, the Raton Coal and Coke Company, established the first coal mine in Colfax County at Blossburg in Dillon Canyon in 1881. Its primary purpose was to supply fuel for the railroad's locomotives. Dr. James Shuler, a physician from Raton, administered to the miners and their families. The first telephone line in the county, which ran along barbed-wire fences, was installed from his house to the camp at the turn of the century. (Arthur Johnson Memorial Library.)

Raton artist Manville Chapman painted a rendition of life at the Blossburg camp in this mural displayed in the lobby of the Shuler Theater in Raton. The town was named by the mine boss, Col. Edward Savage, after his hometown in Pennsylvania and once held over 1,000 inhabitants. Mine explosions in 1894, 1903, and 1906 left the town practically deserted. (Authors' collection.)

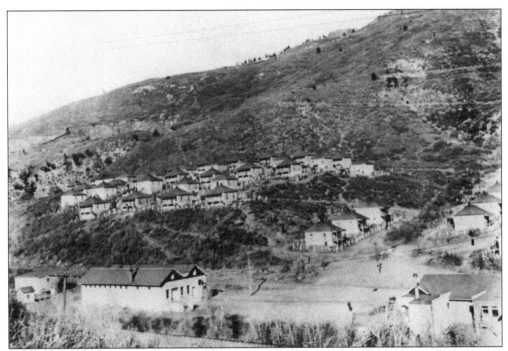

The coal mining town of Sugarite was developed by the Chicorica Coal Company in 1912. Located in Chicorica Canyon northeast of Raton, the town boasted 500 residents in 1915 when it was acquired by the St. Louis, Rocky Mountain & Pacific Company. The mine was closed and abandoned in 1941, and the site is now a New Mexico state park. (Arthur Johnson Memorial Library.)

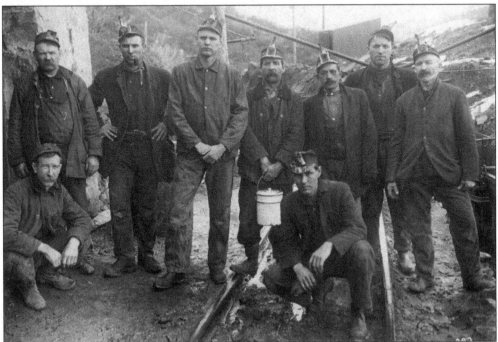

These coal miners at Sugarite took time off to pose with their headlamps and a lunch bucket. (Arthur Johnson Memorial Library.)

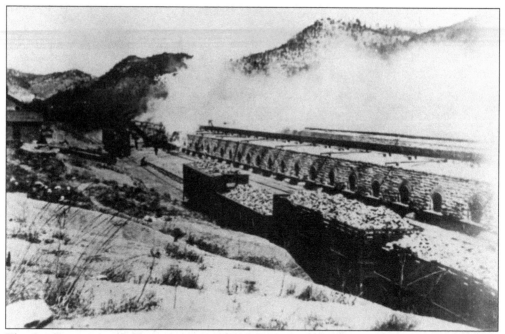

The Gardiner coal mine was opened by the Raton Coal and Coke Company and owned by the Santa Fe Railway. Located three miles west of Raton, it had a battery of 300 coke ovens; the mine shut down operations in 1940. (Arthur Johnson Memorial Library.)

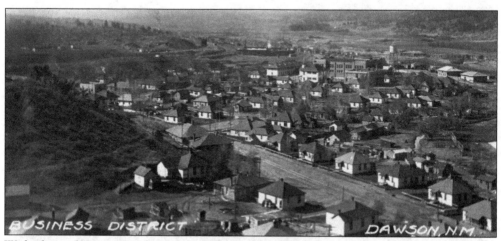

With almost 600 company houses, Dawson was the largest coal town in the area. Rent for the largest was $8 per month, or roughly half of what a similar residence in Raton cost. The miners lived in clusters of their own nationality, whether it be Polish, Italian, Greek, or Irish. By and large, coal miners got along well together and there was little racial or ethnic conflict. (Arthur Johnson Memorial Library.)

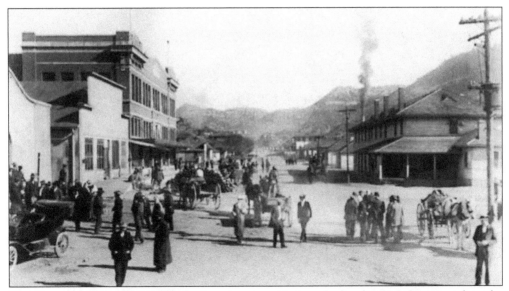

Dawson was a modern industrial city boasting a population of more than 9,000 at its peak in the 1920s and 1930s. It possessed all of the amenities a miner and his family could want including an opera house, a swimming pool, and several tennis courts. The Dawson mercantile store is the large three-story building on the left. (The Old Mill Museum.)

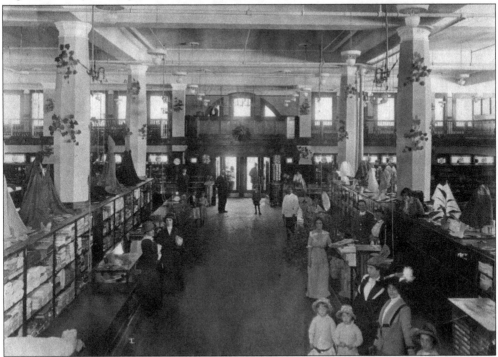

The Phelps Dodge Corporation built a mercantile at Dawson in 1913. The store provided a wide range of goods and clothing for miners and their families. As part of their wages, most miners were issued scrip that could be redeemed at the store. The Phelps Dodge Mercantile's slogan was "We can supply your needs from beans to bread, and from mouse traps to tractors." Prices were competitive with stores in surrounding towns. (Arthur Johnson Memorial Library.)

Phelps Dodge built a modern 26-bed hospital and medical dispensary at Dawson in 1906 to care for injured miners and family members who became ill. Five doctors were on staff, and the hospital boasted both surgery and X-ray rooms. (Randall M. MacDonald.)

In the March 23, 1923, *Dawson News* is a report on the amount of donations received to be used in building a new clubhouse for the local Boy Scouts. The following contributions were received: Dawson Troop No. 1, $150; Dawson Troop No. 2, $25; *Dawson News*, $5; G.L. Fenson (school superintendent), $5; and basketball game receipts, $18.80. (Arthur Johnson Memorial Library.)

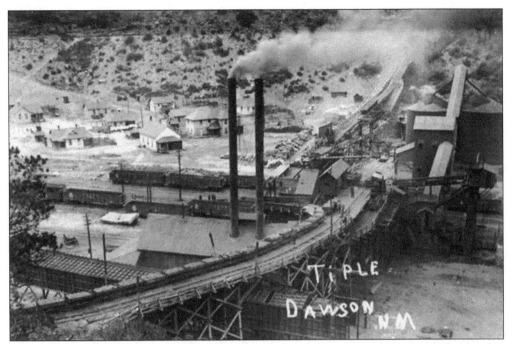

When loaded carts came out of the mine, they entered the upper level of a tipple like this one at Dawson. Each cart was then tipped over manually, hence the name *tipple*, whereby its contents fell down a chute that led into a railroad hopper car positioned underneath. (The Old Mill Museum.)

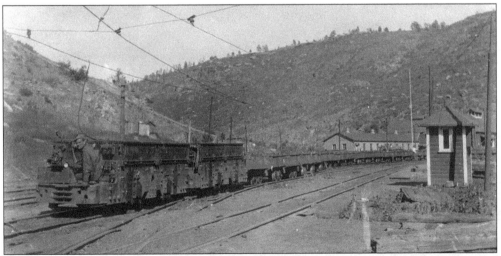

By the late 1920s, electric locomotives were used to pull loaded coal carts from the 10 different mines at Dawson. The introduction of larger coal carts than those used during earlier mule-drawn days tripled mine production. (Arthur Johnson Memorial Library.)

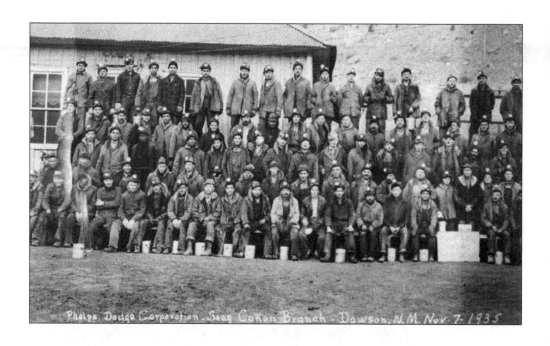

Stag Canyon Fuel Company miners are pictured above with their ever-present lunch buckets in November 1935. Note how each miner wears a heavy coat. Even during the heat of summer, the underground mines were known to be surprisingly cold. Each miner carried a lunch pail or bucket to work. Inside were usually two sandwiches with an apple packed on top. The bottom portion contained a gallon of water. Conditions were harsh for men working in the coal mines of Colfax County. Aside from cold temperatures underground, mines were filled with volatile coal dust until water sprayers and ventilators were installed. Still, many miners contracted black lung disease from breathing coal dust. (Both, Arthur Johnson Memorial Library.)

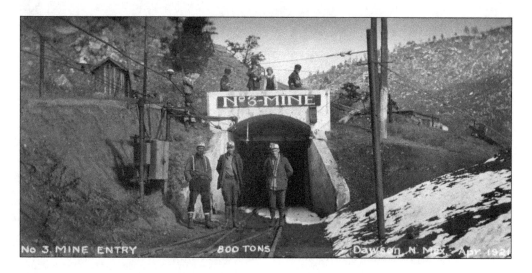

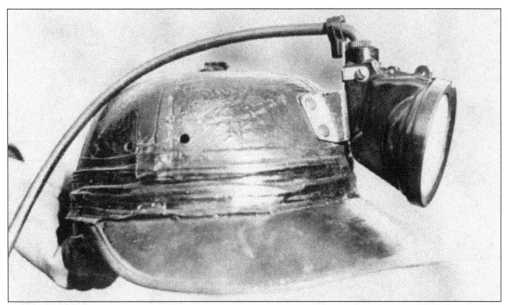

Every coal miner's first stop in the morning was the lamp house where he picked up his helmet with a recharged lamp and a brass check, which was a round disk with his individual number on it. When the men came out of the mine after their shift, they were required to return their helmets and brass checks so that the guardian of the lamp house would know when the mine was clear. (Arthur Johnson Memorial Library.)

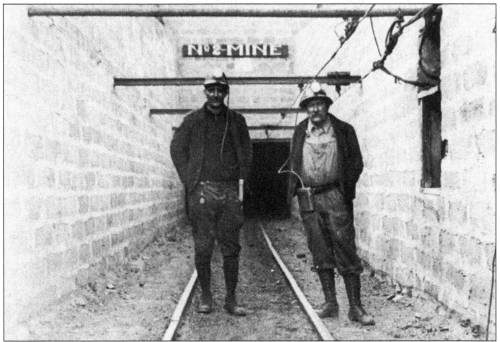

Dawson Mine No. 2 was the site of the second-worst coal mine disaster in US history. On October 22, 1913, a dynamite charge was set off that ignited coal dust in the mine. Because the mine was in operation at the time, 263 miners out of 286 who were working in the mine perished; the explosion was felt in town, two miles away. (Arthur Johnson Memorial Library.)

This photograph of Dawson's junior high school 1937 basketball team includes, from left to right, (first row) Lino Ghiglieri, Mike Hernandez, Tony DiLuz, and Eddie Zamora; (second row) unidentified, Danny Carlini, Paul Berela, Chico Calderon, and coach Leroy Brannon. The child in front is identified as the coach's son. (Arthur Johnson Memorial Library.)

Dawson's high school was one of the few accredited institutions found in any New Mexico coal camp in the first half of the 20th century. Dawson was perennially known for the strength of its athletic teams, including the soccer team. Raton High School was its greatest rival, and the stands were filled to overflowing when the schools played each year, whether in Dawson or Raton. (Arthur Johnson Memorial Library.)

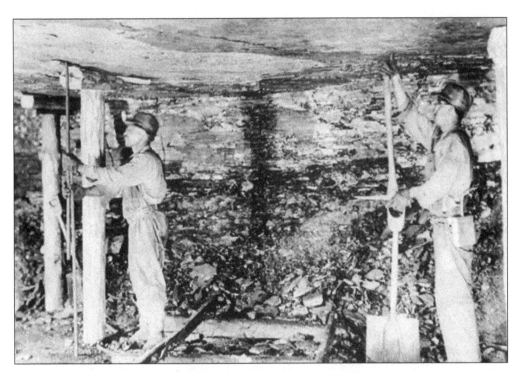

Two unidentified Dawson miners are shown in this photograph of a propped-up underground mine room. After coal was broken away from a seam during nightly dynamite explosions, the miners entered the mine the following morning and shoveled the dislodged coal into mine carts such as the one shown below. The cart was then shuttled outside to the tipple where its load of coal was dumped down a chute into a waiting railcar. (Both, Arthur Johnson Memorial Library.)

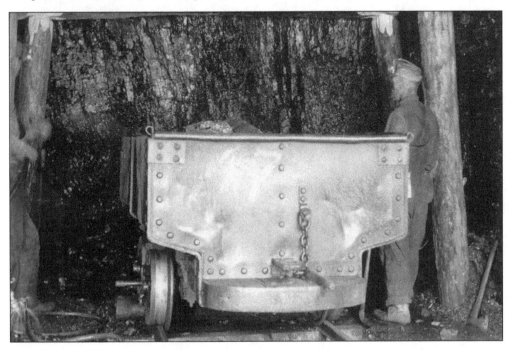

In the early years of coal mining, miners dug coal by hand using pickaxes, hammers, and drills. They shoveled coal into railcars that were drawn out of the mine by faithful, hardworking mules. (Authors' collection.)

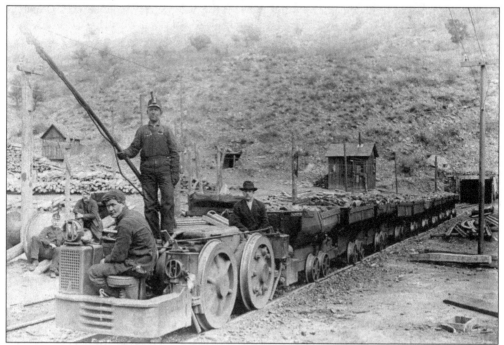

In the late 1910s, small locomotives that were first powered by steam, and later by electricity, replaced mules. This allowed the introduction of larger coal cars, resulting in a substantial increase in coal production. (The Old Mill Museum.)

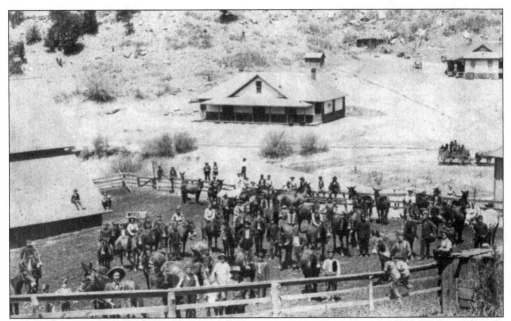

One Dawson miner remarked that he "used to get so mad at the mules I wanted to kill 'em. But you couldn't kill a mule. You could kill a man in Dawson then, but you couldn't kill a mule." (Arthur Johnson Memorial Library.)

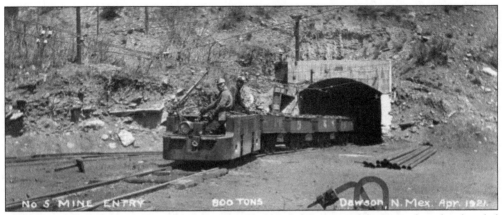

This electric locomotive at Dawson not only pulled loaded cars out of the mines but also shuttled men to and from the mines. At the height of its activity in the 1920s and 1930s, Dawson had 10 separate mines and employed more than 1,500 miners. (Arthur Johnson Memorial Library.)

Like Phelps Dodge at Dawson, the St. Louis, Rocky Mountain & Pacific Company established mercantile stores at each of its coal camps. They were known for being able to supply all of the wants and needs of the miners and their families at reasonable prices. Solitaire was a popular supplier of grocery items during the first half of the 20th century in the West. (Arthur Johnson Memorial Library.)

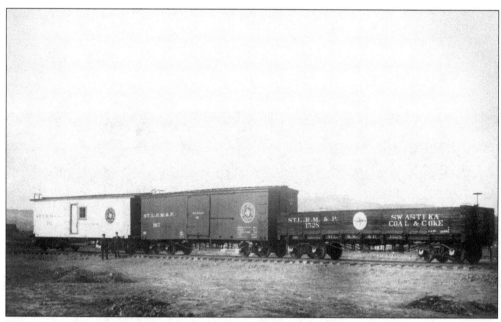

Hopper cars like the one on the right were used by the St. Louis, Rocky Mountain & Pacific Railway to transport coal and coke from company mines such as Brilliant, Koehler, and Van Houten to their eventual destinations. (The Old Mill Museum.)

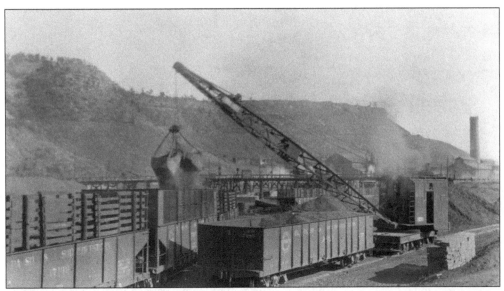

These El Paso & Southwestern railcars are being loaded with Dawson coal for shipment to Phelps Dodge's copper mines in southern Arizona. This railway line was a subsidiary of the Phelps Dodge Corporation, which had purchased the Dawson Railway from Charles Eddy in 1905. (Arthur Johnson Memorial Library.)

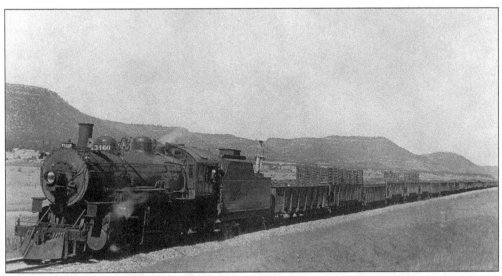

The cars behind this El Paso & Southwestern steam locomotive are loaded with coke from Dawson. The train is headed out of Vermejo Canyon and will cross the Santa Fe line at the town of French in eastern Colfax County. From there, it would proceed to Tucumcari and El Paso and on to mines like the Copper Queen Mine in Bisbee, Arizona, where the coke would be used to smelt copper ore. (Arthur Johnson Memorial Library.)

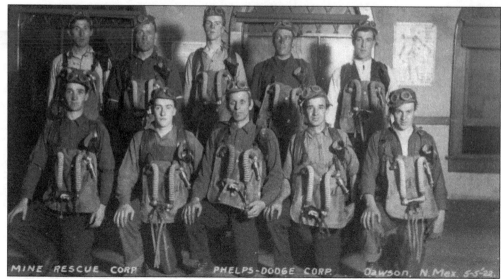

The Dawson mine rescue team is pictured in 1922. The team practiced regularly so it would be ready in any emergency. Even though safety was of utmost concern to the company, two horrific mine accidents occurred at Dawson. In addition to the disaster that occurred in Mine No. 2 in 1913, which also took the lives of two rescuers, a second explosion in Mine No. 1 on February 8, 1923, killed 123 men. Many who died in the later explosion were sons of those who perished a decade earlier. (Arthur Johnson Memorial Library.)

The graves in Dawson's cemetery are primarily those of the miners who perished in the horrific 1913 and 1923 mine accidents. The cemetery is located down the Vermejo Valley from the remnants of what used to be the town of Dawson. Descendants of the fallen miners visit it many times annually. (Authors' collection.)

Six

LUMBERING

Today, the dense forests that cover the mountains and plateaus of western Colfax County are a rich haven for wildlife. Species as diverse as the golden-mantled chipmunk, black bear, long-tailed weasel, elk, mule deer, and turkey are frequently spotted by observant hunters and campers as they trek through the woods. Trees are largely viewed in terms of their aesthetic and ecological value and not their economic value.

During frontier times, however, the great stands of ponderosa pine and Douglas fir represented an important economic resource that brought hundreds of lumbermen to the mountains wishing to harvest them and turn them into railroad ties and mine timbers. But before the trees could be cut, rail lines had to be built in order to transport the logs out. As a result, a number of lumber camps sprouted at intervals along the tracks.

In 1890, the vast forests of pine and fir in the northern part of Colfax County along the Canadian River drew officials of the Fort Worth & Denver Railway wishing to harvest them. They leased large timberland parcels from the Maxwell Land Grant Company and built 16 miles of track into the mountains, establishing the Catskill lumber camp. Within a year, the camp boasted a school, two hotels, several restaurants and saloons, two mercantiles, and a community water system.

Along with felling trees to make railroad ties and mine props, the loggers cut them to be processed into charcoal. Two sets of brick ovens were erected at the camp for the operation. The logging venture was successful for several years, represented by the $110,000 in lumber royalties that was paid to the land grant company in 1893. However, royalties dropped to $30,000 four years later. By 1890, the forest within proximity to the camp had been clear-cut, which led to the abandonment of the rail line. Catskill was virtually a ghost town by the following year.

In the southern part of Colfax County, Thomas Schomburg organized the Cimarron Tie & Lumber Company in 1906 to cut timber in North Ponil Canyon northwest of Cimarron. To transport the felled logs, Schomburg established the Cimarron & Northwestern Railway that built 22 miles of track into the canyon the next year. Loggers followed close behind, eventually establishing logging camps at Ponil Park, Ring, and Bonita Canyon. By 1923, all of the available timber had been cut in the North Ponil country, so the company abandoned its camps and pulled up the line's tracks. In turn, it recycled them and built a road up the Middle and South Ponil Canyons all the way to the foot of Wilson Mesa. Having exhausted the supply of trees there by the end of the decade, the railroad was abandoned, and the tie and lumber company suspended operation. The ringing of axes and the puff of the locomotive were heard no more.

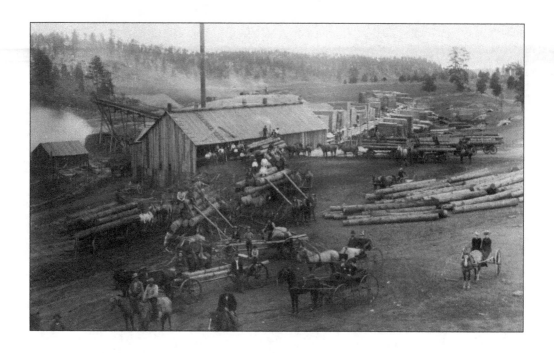

Heavy logs from old-growth trees were hauled to several mills near Catskill such as McAlpine's (above) and Blethens' (below) in 1893. Mills were licensed to produce hewn railroad ties; telegraph, telephone, electric, and light poles; mining props; stockyard and fence posts; and cordwood from trees too small to scale. (Both, Arthur Johnson Memorial Library.)

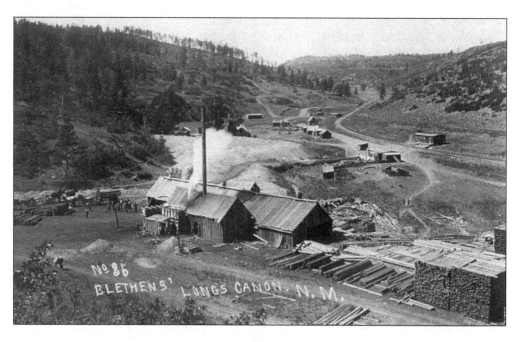

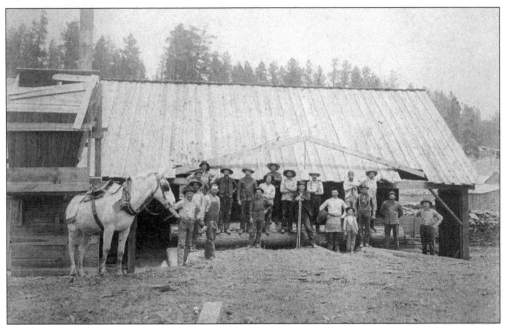

Workers at Blethens' Mill near Catskill worked long hours under harsh conditions. Although the work was dangerous, they were well paid. Horses, like the one pictured here, were used to haul logs around the yard or out through difficult terrain, where they could more easily be bucked (cut to length), limbed, and scaled before being transported to the mill for debarking and decking (sorting). (Arthur Johnson Memorial Library.)

Timber royalties paid to the Maxwell Land Grant Company by lumbermen working out of Catskill totaled more than $100,000 in 1893. (Arthur Johnson Memorial Library.)

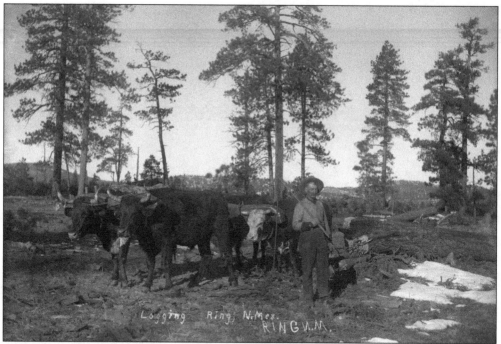

Some loggers used oxen rather than horses to skid out logs from the woods. Oxen were strong and dependable although somewhat slower than horses. By the turn of the 20th century, the skill of driving oxen had, by and large, been lost. (Randall M. MacDonald.)

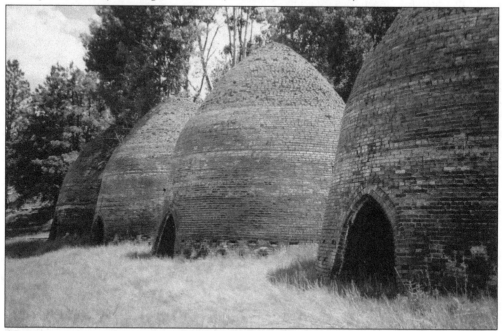

Charcoal was an important product made from trees. Two sets of massive brick ovens dominated the Catskill camp—one group consisting of 10 ovens; the other, 14. Each oven was almost 30 feet high and 30 feet in diameter, and they are in a remarkable state of preservation even today. (Authors' collection.)

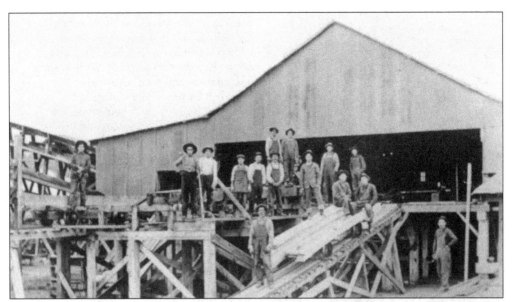

Lumber was rough cut at company mills in Ponil Park and Ring and then transported by railcar to be trimmed, dried, and planed at Cimarron Tie & Lumber Company's planing mill in Cimarron. (Philmont Museum.)

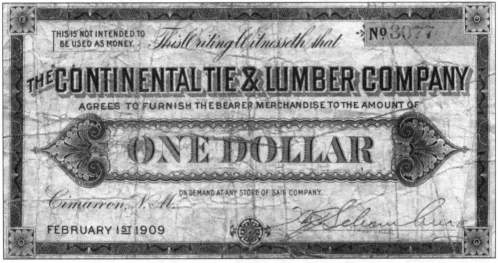

In lieu of wages to its employees, the Continental Tie & Lumber Company often issued scrip that could be redeemed for goods only at the company's stores in Cimarron, Ponil Park, and Ring. (Philmont Museum.)

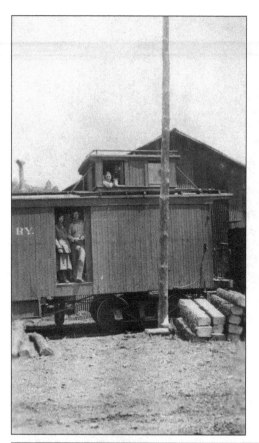

Stacked on the ground at the lower right are railroad ties that have been hewn by hand from red spruce logs. Ties were shipped on the Cimarron & Northwestern to Cimarron and then on to either Trinidad, for use by the Colorado & Southern Railway, or Albuquerque, for the Santa Fe. (Philmont Museum.)

General Manager H.G. Frankenberger of the Cimarron & Northwestern Railway often issued free tickets for railroad trips to Ponil Park and Ring. Sometimes, trains were stopped so that passengers could hunt or fish. On weekends, families would travel down the line to Cimarron to enjoy a bit of "city life" and spend what little money they had earned during the week on goods not available in company stores. (The Old Mill Museum.)

The Cimarron & Northwestern R'y Co.

OF NEW MEXICO

One FIRST CLASS Passage

—TO—

Good only on Date of Sale Stamped on Back.

H.G. Frankenberger

General Manager

5001

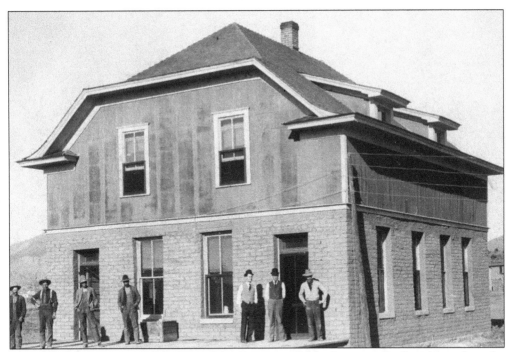

These workers are seen at the office of the Cimarron & Northwestern Railway located on the east side of Cimarron. (Raton Museum.)

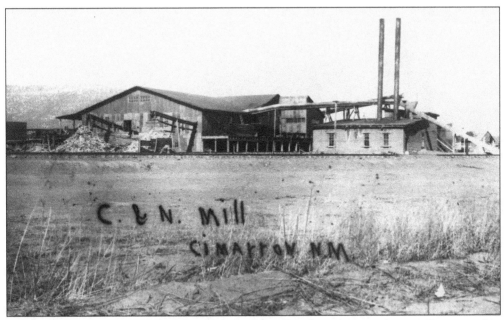

The Continental Tie & Lumber Company built a railroad tie treating plant in Cimarron that opened in 1915. At one point in that year, the company had orders for 100,000 ties that took more than two months to supply. (The Old Mill Museum.)

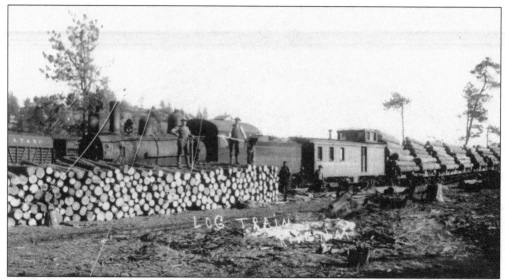

This Cimarron & Northwestern train is being loaded at Ring with bucked (cut-to-length) mine props for shipment to Cimarron. From there, they would be transported via St. Louis, Rocky Mountain & Pacific tracks to Ute Park before being taken up by road to the gold mines on Baldy Mountain. (The Old Mill Museum.)

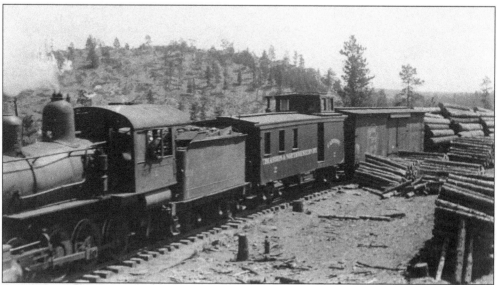

Vast stands of ponderosa pine and Douglas fir were harvested out of the Ponil country northwest of Cimarron after the turn of the 20th century. Bucked logs were loaded onto this Cimarron & Northwestern train and hauled to Cimarron to be processed into railroad ties and mine props. (The Old Mill Museum.)

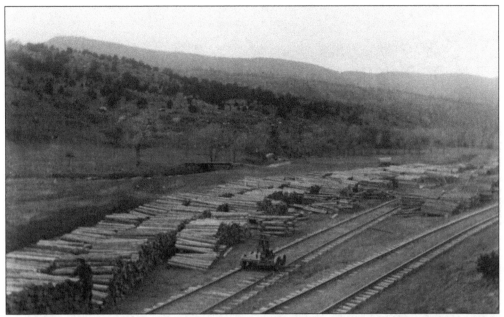

Here, mine props are stacked at Continental Tie & Lumber Company's storage yard west of Cimarron. Props were cut from five to nine feet long and were usually made of peeled red spruce logs, which could better withstand the deteriorating effects of the mines. The St. Louis, Rocky Mountain & Pacific Company bought most of the ties for its Raton coal mines. (The Old Mill Museum.)

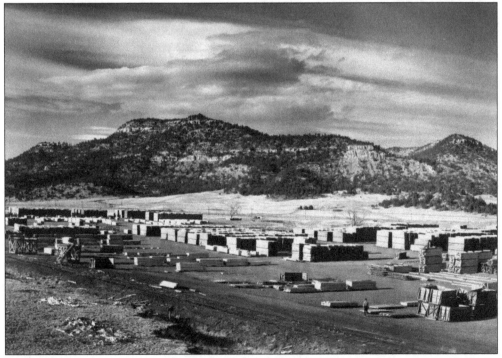

Finished boards are seen in the storage yard, ready to be loaded onto railcars and shipped east by the St. Louis, Rocky Mountain & Pacific Railway. (Raton Museum.)

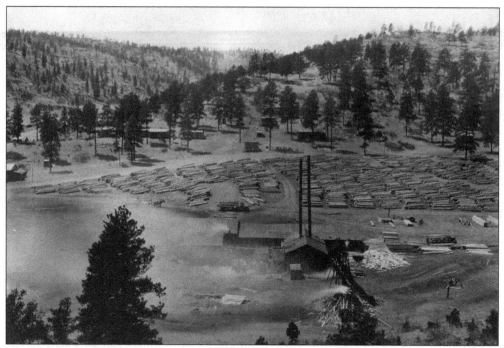

The lumber mills at Ponil Park, Ring, and Bonita often employed 125 men each and were capable of producing more than 60,000 feet of lumber per day, enough to fill five railroad cars. (Raton Museum.)

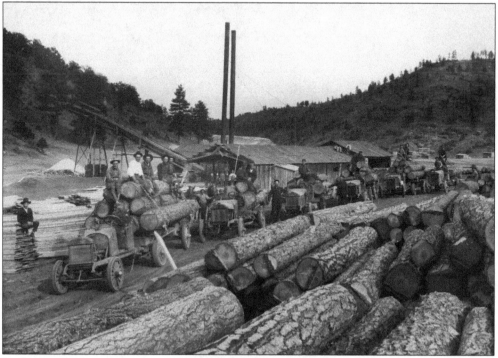

By the late 1910s, many companies had switched to trucks to transport logs to the lumber mills in the North Ponil valley. (Raton Museum.)

Many loggers brought their families to the North Ponil where they worked. The families most often lived in crude log cabins that were quickly built near where the loggers were working. The cabins were abandoned as soon as the trees in the surrounding area were harvested. Schools, such as the one shown above and below, were erected near the larger camps to ensure that the children's education was not neglected. (Both, the Old Mill Museum.)

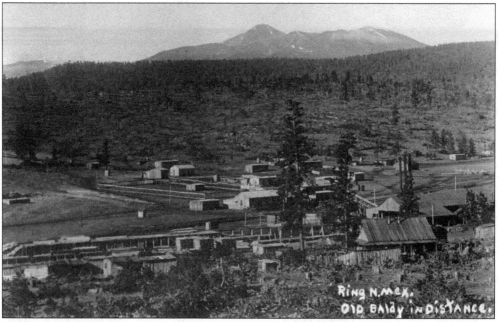

This photograph of the Continental Tie & Lumber Company's camp at Ring shows Baldy Mountain in the background. Each camp along the North Ponil had a single wire telephone, a store, and a post office with mail delivered daily. (The Old Mill Museum.)

Loggers in the North Ponil woods used two-handed crosscut saws to fell trees. After the trees were downed, axmen trimmed off the branches in a process called limbing to prepare them for skidding to the railroad siding. Even with hand tools such as these, loggers successfully clear-cut most of the North Ponil forest in less than 20 years. (The Old Mill Museum.)

These loggers are shown with old-growth logs at Ring on Christmas Day 1911. These massive pine logs were typical of what was harvested in the Ponil country. (The Old Mill Museum.)

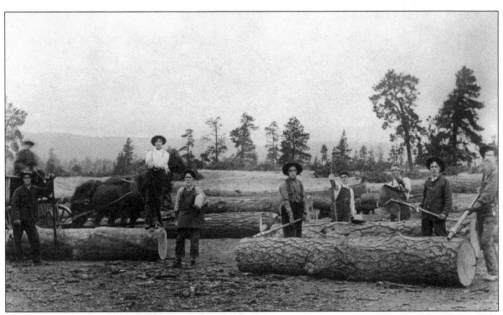

The two loggers in the right foreground demonstrate how massive logs were moved using a long-handled cant hook called a peavey. (The Old Mill Museum.)

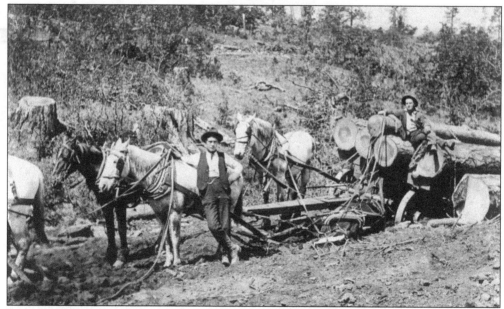

Despite the use of horsepower, bringing logs out of the upper side of canyons was often difficult during the rainy summer season because the heavily laden wagons would bog down in the deep mud. (The Old Mill Museum.)

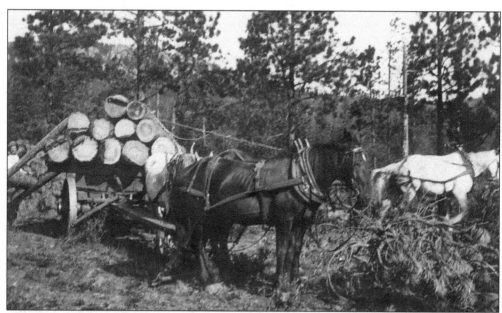

Logging crews could cut as many as 100 trees each day depending on the size of the timber. Teams of draft horses dragged or skidded the logs out of the forest to wagons where they were hauled down to the railroad. (The Old Mill Museum.)

BIBLIOGRAPHY

Caffey, David. *Frank Springer and New Mexico*. College Station: Texas A&M University Press, 2006.

Cleaveland, Agnes Morley. *Satan's Paradise*. Boston: Houghton Mifflin, 1952.

Hilton, Tom. *Nevermore, Cimarron, Nevermore*. Fort Worth, TX: Western Heritage Press, 1970.

Keleher, William A. *Maxwell Land Grant: A New Mexico Item*. Santa Fe, NM: Rydal Press, 1942.

MacDonald, Randall M., Gene Lamm, and Sarah E. MacDonald. *Cimarron and Philmont*. Charleston, SC: Arcadia Publishing, 2012.

Montoya, Maria E. *Translating Property: The Maxwell Land Grant and the Conflict over Land in the American West, 1840–1900*. Berkeley: University of California Press, 2002.

Murphy, Lawrence R. *Lucien Bonaparte Maxwell: Napoleon of the Southwest*. Norman: University of Oklahoma Press, 1983.

———. *Philmont: A History of New Mexico's Cimarron Country*. Albuquerque: University of New Mexico Press, 1972.

Pappas, Mike. *Raton: History, Mystery, and More*. Raton, NM: Coda Publications, 2003.

Pearson, Jim Berry. *The Maxwell Land Grant*. Norman: University of Oklahoma Press, 1961.

Smith, Toby. *Coal Town*. Santa Fe, NM: Ancient City Press, 1993.

Stanley, Francis. *The Grant That Maxwell Bought*. Denver, CO: World Press, 1952.

Taylor, Morris F. *O.P. McMains and the Maxwell Land Grant Conflict*. Tucson: University of Arizona Press, 1979.

Tiller, Veronica E. Velarde. *The Jicarilla Apache Tribe: A History, 1846–1970*. Lincoln: University of Nebraska Press, 1983.

Zimmer, Stephen, and Steve Lewis. *It Happened in the Cimarron Country*. Parker, CO: Eagle Trail Press, 2013.

Visit us at
arcadiapublishing.com

CPSIA information can be obtained
at www.ICGtesting.com
Printed in the USA
LVHW050326220720
661199LV00010B/270